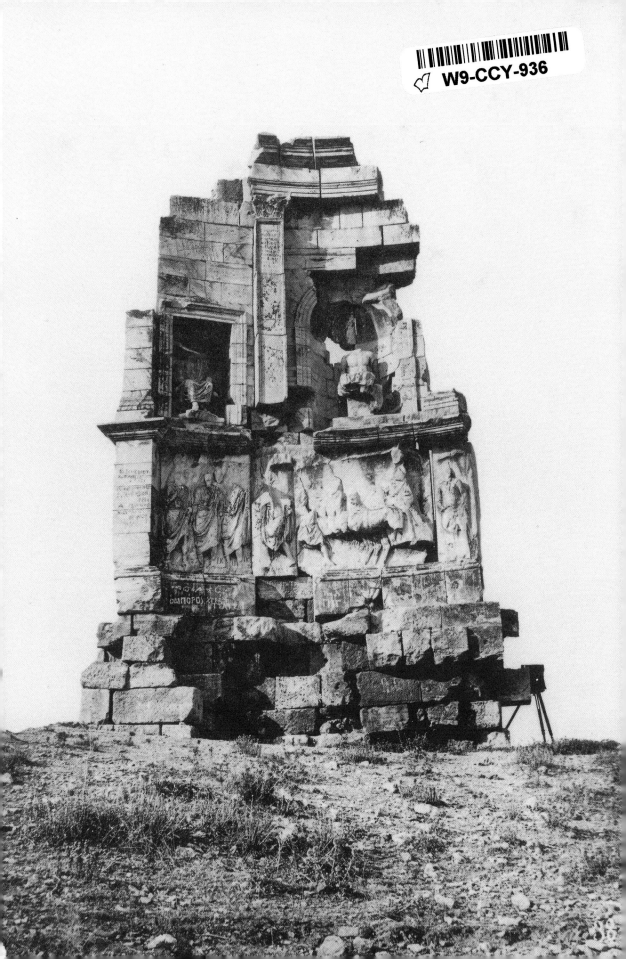

Published by the Getty Research Institute for the History of Art and the Humanities

Irresistible Decay:
Ruins Reclaimed
Michael S. Roth with Claire Lyons
and Charles Merewether

Bibliographies & Dossiers

The Collections of the Getty Research Institute for
the History of Art and the Humanities, 2

The Getty Research Institute Publications and Exhibitions Program

Bibliographies & Dossiers
The Collections of the Getty Research Institute for the History of Art and the Humanities
Julia Bloomfield, Harry F. Mallgrave, JoAnne C. Paradise, Thomas F. Reese, Salvatore Settis, *Editors*

Irresistible Decay: Ruins Reclaimed
Lynne Kostman, *Managing Editor*
Lynne Kostman and Rebecca Frazier, *Manuscript Editors*

This volume accompanies the exhibition *Irresistible Decay: Ruins Reclaimed,*
held December 16, 1997, through February 22, 1998, at the Getty Center, Los Angeles.

Published by The Getty Research Institute
for the History of Art and the Humanities,
Los Angeles, CA 90049-1688
© 1997 by The Getty Research Institute
for the History of Art and the Humanities
All rights reserved. Published 1997
Printed in the United States of America.

03 02 01 00 99 98 97 7 6 5 4 3 2 1

Frontispiece: Constantine Athanassiou, view of Philopappos Monument, Athens,
ca. 1875, albumen print. Los Angeles, The Getty Research Institute for the History of
Art and the Humanities, acc. 92.R.84 (04.11.03).

Library of Congress Cataloging-in-Publication Data
Irresistible decay: ruins reclaimed / Michael Roth with
Claire Lyons and Charles Merewether.
p. cm. —(Bibliographies & dossiers: the collections of the Getty Research Institute for
the History of Art and the Humanities; 2)
Includes bibliographical references.
ISBN 0-89236-468-8 (pbk.)
1. Ruins in art — Exhibitions. I. Roth, Michael S., 1957– .
II. Lyons, Claire L., 1955– . III. Merewether, Charles.
IV. Getty Research Institute for the History of Art and the Humanities. V. Series.
N8237.8.R817 1997
930.1′074′79493 — dc21 97-14118
 CIP

Contents

vii Foreword

ix Acknowledgments

xi Preface

1 Irresistible Decay: Ruins Reclaimed
Michael S. Roth

25 Traces of Loss
Charles Merewether

41 Refinding the Past: Ruins and Responses
Compiled by Michael Roth

79 Archives in Ruins:
The Collections of the Getty Research Institute
Claire Lyons

100 Selected Bibliography

105 Image and Quotation Credits

106 Checklist of the Exhibition

Foreword

Ruins signal simultaneously an absence and a presence; they show, they *are*, an intersection of the visible and the invisible. Fragmented, decayed structures, which no longer serve their original purpose, point to an absence —a lost, invisible whole. But their visible presence also points to durability, even if that which *is* is no longer what it once was.

Ruins speak to us in ways that things made by Nature cannot. In their persistent presence, ruins speak to us of the structures they once were, of the people who made them, of those who commanded them to be made, and of those who for a time made use of them. In their evocation of absence, they speak of those who destroyed them or abandoned them or failed to protect them from the irresistible ravages of Time. In their present state, ruins speak of those who have tried to make sense of them, or have been drawn to represent them, or have used them as objects of memorialization.

Ruins potently epitomize the perennial tension between what is preserved and what is lost, what seems immediately understandable (or usable) and what needs interpretation (or reconstruction). As we have learned that trauma and discontinuity are fundamental for memory and history, ruins have come to be necessary for linking creativity to the experience of loss at the individual and collective level. Ruins operate as powerful metaphors for absence or rejection and, hence, as incentives for reflection or restoration.

Irresistible Decay: Ruins Reclaimed, the book that I have the great pleasure of introducing, is a companion volume to the Getty Research Institute's exhibition of the same name. The theme of ruins is widely represented in our collections, and therefore it naturally suggests itself as the focus of one of our exhibitions. This exhibition and this publication thus contribute toward our goal of increasing awareness in the scholarly community and the larger public of the wealth of primary materials housed in the Research Institute's collections.

I would like personally to thank Michael Roth, Claire Lyons, and Charles Merewether for the time and care they have devoted in preparing both the exhibition and this volume. For many visitors, this "irresistible" subject matter will provide an initial glimpse—a prelude, I hope, to a broader knowledge—of the Research Institute's vast and significant holdings of primary materials.

—Salvatore Settis, Director, The Getty Research Institute for the
History of Art and the Humanities

Acknowledgments

This project has been a joint effort from the start. The co-curators of the exhibition, Claire Lyons, Charles Merewether, and myself, have also worked jointly on this publication. Although we have written separate pieces, we have discussed the volume as a whole. At every stage of the project the assistance of Charles Salas has been decisive. He has helped us clarify some of the key issues and made it possible for us to turn our ideas into a book and exhibition.

Together we have worked under the auspices of the Getty Research Institute and have found it to be a rich resource not only in materials but also in expertise. Our project by no means reflects the Research Institute as a whole, but in one way at least it does reflect one of the Research Institute's guiding tenets: the willingness to bring scholars from different disciplines and using different methodologies to work together on a common theme. The initial idea for an exhibition on "Ruins" came from Salvatore Settis, Director of the Research Institute, who gave us the freedom to approach the theme as we wished and also gave us his criticisms in the areas where our work could be improved. We are grateful to him for both. We are likewise grateful for the suggestions made about our essays by our colleagues Thomas Reese and JoAnne Paradise.

In putting the exhibition together we have been aided by many here at the Research Institute. Marcia Reed pointed us to materials, Fran Terpak helped us with the photographs, Louise Hitchcock and Alex Waintrub provided timely research assistance, Deborah Derby worked around our frenetic schedule in readying the materials for exhibition, and Barbara Anderson ably coordinated logistics between the Research Institute and the J. Paul Getty Museum. Wim de Wit and Beth Guynn of the Research Institute's Special Collections Department were always gracious in dealing with our many questions; our thanks go to them and the entire Special Collections staff, without whose assistance the exhibition would not have been possible. William Stapp and Kenneth Jacobson went out of their way to answer our questions. Special thanks must go to Don Williamson's photographic team of Robert Walker and John Kiffe, who handled our many extraordinary requests with aplomb.

We are also indebted to Weston Naef, Curator of Photographs at the J. Paul Getty Museum, for allowing us to borrow materials for the exhibition and to members of his staff Julian Cox and Anne Leyden for helping us to

find and document them. From Sonnabend Galleries we borrowed *Memoria Mundi (No. II)*, created by Anne and Patrick Poirier, and our thanks go to Sonnabend and the Poiriers. John Weber Gallery in New York allowed us to reproduce the Robert Smithson photograph, for which we are grateful.

This book has been designed by Bruce Mau and Chris Rowat, and produced by the Research Institute's Publications Department, headed by Julia Bloomfield. Lynne Kostman and Rebecca Frazier went beyond the call of duty in making numerous editorial suggestions which greatly improved the essays, and Tyson Gaskill used a keen eye in checking the bibliography. We are grateful to the Publications Department for their flexibility and purposefulness. The care they have taken with this project is worthy of the objects it attempts to portray.

—Michael S. Roth

Preface

I*rresistible Decay: Ruins Reclaimed* is a companion volume for the exhibition of the same name held at the Getty Center from December 16, 1997, to February 22, 1998. Although not a catalog in the conventional sense, it offers an overview of the exhibition's basic structure, interpretations of and meditations upon some of its central themes, and indications of how the collections of the Getty Research Institute for the History of Art and the Humanities might be useful for further research in this general area.

The title *Irresistible Decay* is borrowed from Walter Benjamin's *The Origin of German Tragic Drama*. Benjamin wrote of ruins as "allegories of thinking":

> The word "history" stands written on the countenance of nature in the characters of transience. The allegorical physiognomy of the nature-history...is present in reality in the form of the ruin. In the ruin history has physically merged into the setting. And in this guise history does not assume the form of the process of an eternal life so much as that of irresistible decay. (177–78)

Ruins are emblematic of transience and of persistence over time. Both dimensions are crucial to an understanding of the material selected for the exhibition and this volume.

The exhibition is composed of three overlapping sections: "Production and Framing," "Recycling, Reconstruction, and Preservation," and "Loss, Recuperation, and Identity." The first of these sections focuses on the process through which a decayed object comes to be framed as a ruin—in other words, how an object or a place is transformed into a physical trace of the past that expresses its own process of decay. The second section of the exhibition, "Recycling, Reconstruction, and Preservation," examines what one *does* with a ruin: how one treats it, cares for it, studies it. Ruins are often activated in a culture to perform certain social, political, or aesthetic functions, but they can never belong fully to the present without losing their status *as* ruins. The final section of the exhibition, "Loss, Recuperation, and Identity," is concerned with how we configure the loss of the past through ruins and how Europeans looking for the "deep past" found it in Latin America and Asia. To whom does the past belong, and—if it is no longer present to us—how do we reclaim it?

The curators of this exhibition have attempted to provide a variety of per-spectives on how objects and sites have been framed as ruins. We have tried to present some of the major dimensions of that attraction in both the exhibi-tion and this book. My essay takes its orientation from the structure of our exhibition but moves from that structure to consider some themes central to the framing of ruins in European culture. I discuss the ruin as something con-structed by a beholder as a decayed trace of the past. The decay conveys the threat that the trace—and hence the past—is fragile and can be lost; but the decay is also a deep component of our attraction to and care for the trace. The dilemma becomes how to preserve the process of decay while arresting time in order to preserve the trace being decayed. Charles Merewether's essay concentrates less on the attractions of decay than on the necessities and oblig-ations of living with it, living among ruins that recall us to (but remind us of our distance from) the past. His focus is on the late twentieth century, a period in which some have claimed that culture itself has become a ruin—a fragment of a lost, even if only imaginary, whole. He is interested in how ruins connote loss while promising a connection to what has been but is no more. The condition of loss and the problem of connection are core dilemmas for many contemporary artists and architects, and Merewether zeroes in on how they re-present the absent.

The next section of the book is a collage of quotations and of illustrations drawn from the exhibition. Word and image will, I hope, work in relation to each other to give the reader some sense of the experience of ruins and the history of meditations upon them. There are no necessary historical connec-tions between the quotations and the images, but readers are invited to turn to the pictures with the words in mind and to turn back to the words having considered the pictures. The selection of quotations is not at all systematic; it represents instead my attempt to enrich the reader's experience of the objects we have chosen to exhibit. The final essay and the selected bibliography are invitations to further research. Claire Lyons discusses some of the documen-tation on ruins that makes scholarly work on them possible and how this documentation continues to have an impact on the ways we frame the past. Lyons emphasizes how the holdings of the Getty Research Institute can con-tribute to a scholarly attempt to reclaim ruins for interpretation or explana-tion, or at least can help us understand our investment in the ruinous remains of the past.

Irresistible Decay: Ruins Reclaimed presents scholarly and artistic materi-als along with interpretations or meditations upon them. By doing so, we hope to have raised some issues that continue to be important for under-standing the ways ruins have been constructed by us and the ways we have responded to the calls of these (often falling) constructions.

—Michael S. Roth

Irresistible Decay: Ruins Reclaimed
Michael S. Roth

The past is hidden somewhere outside the realm,
beyond the reach of intellect, in some material
object (in that sensation which that material object
will give us) of which we have no inkling. And it
depends on chance whether or not we come upon
this object before we ourselves must die.

— Marcel Proust

There lies the better part of my past. What persists,
writing recovers in fragments. Write, write, write
in order to remember. You only understand what
you destroy.

— Edmond Jabès

This volume and the exhibition of the same name draw on the extensive collections of the Getty Research Institute for the History of Art and the Humanities to explore the attractions of decay: the curiosity, *frisson*, reverence, and pleasure that ruins seem to arouse in those who contemplate the past through its physical traces, often its architectural remains. We find ruins in objects that are more than just "a heap of stones" and less than things belonging fully to the present. These objects carry meanings that depend on both the dynamic energies of history and the regular rhythms of nature, and they produce reactions that range from nostalgia to foreboding, from dreams of grandeur to fears of mortality. The word *ruin* has its origins in the idea of falling and has long been associated with fallen stones. When we frame an object as a ruin, we reclaim that object *from* its fall into decay and oblivion and often *for* some kind of cultural attention and care that, in a sense, elevates its value. In the European traditions the classical ruin is elevated out of oblivion into a particularly exalted position of contemplation or even worship. But all ruins are reclaimed, at least in part, because they are vulnerable to the irresistible threat of decay and the uncanny, vertiginous menace of the forces of forgetting. Ruins must remain exposed to these forces in order to have their full effect on the beholder, but they must also be protected from them if they are to survive for us as ruins.

In this essay I would like to introduce the principal themes of the *Irresistible*

Decay exhibition and focus on some of the materials in it that exemplify those themes and their complex interrelationships. The first section of the exhibition, "Production and Framing," focuses on how the remains of decay and fall come to be interpreted as objects that speak to us of the past, how something is framed as a trace of a world to which we no longer have ready access. From antiquarianism to archaeology, from romantic poetry to postmodern photography, writers, artists, and scientists have framed specific sites as embodying a history that is in the process of disappearing. The disappearance, the threat of loss, is key to the attraction of ruins — and to their essential ambiguity. The ambiguity becomes a fertile ground of metaphor, so that bodies, ideas, works of art can be framed as ruins just as buildings can. Objects framed as ruins need our attention and care because they are always threatened by loss, but if we care for them too much, their status as ruins is threatened. Their decay is irresistible to us because it allows us to perceive the passage of time as irresistible. Yet ruins do resist because they persist, but not too well.

One of the most dramatic images from the first section of the exhibition is an illustration from an early anatomical treatise by Charles Estienne, *De dissectione partium corporis humani*, 1545 (p. 42). Here a ruined building pierced by an irregular window forms the backdrop for a body with its chest held open to our gaze. This body is not only "a temple of God," it is already a ruin, a place of death and decay. Yet this image is not intended as a religious warning, nor as a morbid curiosity; it exists instead for the purpose of scientific instruction. The human subject of the woodcut holds open his chest wall and invites the viewer to look into the ruin and learn how something was assembled, how it "worked." Similarly, ruins of classical buildings were often employed to instruct, offering architectural students and practitioners the "skeletons" that would help them understand the principles of building.[1] Skeletal remains thus become the keys to an anatomy of the past, something essential that holds it together. Many later writers and artists would also find the soul of the past in these old bones.

The image from *De dissectione* presents the human body in the context of ruins but also in the context of nature. Foliage seems to sprout from every available crevice on the decaying structure in the background as well as from the earth near the body's feet. Ruins are a trace of the human intervention in nature and evidence of nature's intervention in the human. This long-standing theme has persisted despite changes in both the idea of nature and of the human. It has become especially prominent in modern European writings on ruins and comes into sharp focus in sociologist Georg Simmel's 1907 essay examining the return of the human — or of culture — to nature.[2] Nature is inexorable. As things fall apart, out of their remains emerge new forms of growth. These are signs both of human decay and of reintegration into the natural world.

The force of nature reworking human constructions is vividly depicted in Giovanni Battista Piranesi's eighteenth-century etching of the ruins of an

ancient tomb and aqueduct (p. 44). The human figures depicted in the image climb atop and gesture toward the remains of a tomb partly submerged in water. Vegetation covers the surface of broken columns and springs forth from cracks in the stones. Man is here portrayed as a witness to the process whereby nature reworks a construction into a new form, creating what Simmel would later call something "entirely meaningful, comprehensible, differentiated."[3] Nature expresses itself in the ruin, but of course this expression only speaks to us because Piranesi was there to re-express it, to make this "natural" process a key to his personal project. Piranesi wed his profound antiquarian knowledge to his deep belief in the superiority of Roman to Greek architecture. Indeed, the engraving presents a ruin richly mediated through the antiquarian, "prenationalistic," and artistic vision of its creator. Although Piranesi did begin from the ruins of the ancient aqueduct, even his contemporaries had to be informed which structure inspired his rendering, since the artist depicted his ruin in a state of equipoise between nature and culture that had little apparent connection with the condition of the actual aqueduct's remains. The eighteenth-century artist framed a ruin and thereby stopped the process of ruination, at least from the standpoint of aesthetic contemplation.[4]

In Joseph Michael Gandy's painting of Sparta in the full flower of its glory, *The Persian Porch and the Place of Consultation of the Lacedemonians*, circa 1816 (pp. 46–47), we can see a more extreme version of this process of transformation in representation. Gandy has used Pausanias's descriptions of the ancient city to imagine an anti-ruin — a city that has never decayed and can be rendered in its ancient splendor by the "modern" artist. His image of Sparta floats entirely free of any artifactual remains; he paints the ancient city as he wishes it to have been, before the process of decay and destruction had set in. Many artistic representations of ruins seem to offer this sort of temporal arrest, or at least a temporal rest. Even if the artist does not, like Gandy, imagine a return to a time before the stones began to fall, the process of ruination is contained by the aesthetic frame; natural decay is made part of an artistic project *and stopped*. Every framing creates the possibility in turn of aesthetic reframing, of transmuting the framed ruin into another aesthetic configuration. The physical ruins then become only a distant referent; it is their *representation* that is being re-presented (and reinterpreted) in subsequent artistic renderings. This is especially apparent in René-Jacques Charpentier's ironic appropriation of Piranesi's etching of the sepulchral urn of Marcus Agrippa (figs. 1, 2). Charpentier plays with Piranesi's ruins at the conclusion of a new edition of a sixteenth-century treatise on architecture.[5] Introducing a smiling skeleton with a full head of hair in the foreground, additional scattered ruins and bones, and a plaque bearing the word *fin* (end), Charpentier heralds a tradition that will not only recycle ruins but take them as an occasion for laughing in (on) the face of the gravity and pomposity of ruins imagery.

By the eighteenth century, the taste for decay had become a mark of aesthetic sensitivity for many aristocratic Europeans. But the kind of decay that was to please, the kind that was to call up the pleasurable melancholy that

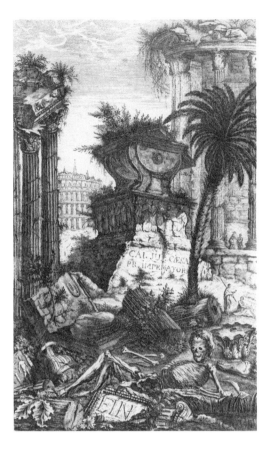

Fig. 1. **René-Jacques Charpentier,** ruins of classical architecture and tomb, engraving from *Livre nouveau; ou, Règles des cinq ordres d'architecture,* 1767. Los Angeles, The Getty Research Institute for the History of Art and the Humanities, acc. 93-B6777.

Fig. 2. **Giovanni Battista Piranesi,** sepulchral urn of Marcus Agrippa, ca. 1740s, etching. Los Angeles, The Getty Research Institute for the History of Art and the Humanities, acc. 900153B*.

writers associated with the contemplation of ruins, was a slow process. Each "survivor" from the past was supposed to convey the fragility of the human endeavor over time. There were only so many ruins that were well-enough preserved (while retaining the proper amounts of picturesque irregularity) to produce the desired mix of emotions in the beholder. For those unlucky aristocrats or wealthy bourgeois who did not have an authentic, venerable, ancient structure nearby, the ingenious solution devised by garden designers of the period was to "create your own ruin." One of the most spectacular of these was the column house in the Désert de Retz, the folly garden of Monsieur de Monville (figs. 3, 4). Folly gardens like this one were fashionable in the eighteenth century. They were triumphs over nature's wildness, but they also included a controlled expression of nature's reclamation of the constructions of man. Like Charpentier's reframing of Piranesi, these artificial ruins reframed decay and fragmentation, making them components of the playgrounds for the rich. The tradition of artificial ruins that was so lively in the eighteenth-century gardens continues today in the freshly fragmented classical motifs decorating the pedestrian malls and campuses of culture that dot our postmodern landscape.[6]

Many of the materials included in the first section of the exhibition illustrate Simmel's point that ruins embody the dialectic of nature and artifice. In Frederick MacKenzie's drawing circa 1840 of the theater at Patara (in present-day Turkey) the decaying buildings seem to be returning to the landscape, becoming once again part of a natural world from which they only appear to have been temporarily separated (pp. 48–49). Ruins here not only signal mortality, they point at a deep belonging to the natural world, a world that is less our inevitable tomb than our eternal home. This is certainly a powerful theme in nineteenth-century romanticism. The poet walking among the ruins does not feel the terror of the sublime but instead is swept along by nature's capacity to integrate different stages of human development into a balanced whole. Nature is not perceived as devouring the works of men and women so much as welcoming them back. After walking near the ruins of Tintern Abbey (pp. 52–53), William Wordsworth wrote:

> That time is past,
> And all its aching joys are now no more,
> And all its dizzy raptures. Nor for this
> Faint I, nor mourn nor murmur; other gifts
> Have followed; for such loss, I would believe,
> Abundant recompense. For I have learned
> To look on nature, not as in the hour
> Of thoughtless youth; but hearing oftentimes
> The still, sad music of humanity,
> Nor harsh nor grating, though of ample power
> To chasten and subdue.

5

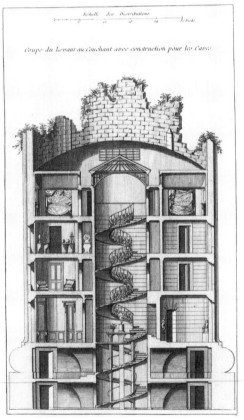

Fig. 3. Georges-Louis Le Rouge, column house, artificial ruin in the Désert de Retz, engraving from *Détail des nouveaux jardins à la mode*, ca. 1776–1787. Los Angeles, The Getty Research Institute for the History of Art and the Humanities, acc. 88·B1922.

Fig. 4. Georges-Louis Le Rouge, cross section of column house (see fig. 3), engraving from *Détail des nouveaux jardins à la mode*, ca. 1776–1787. Los Angeles, The Getty Research Institute for the History of Art and the Humanities, acc. 88·B1922.

Near the ruins of Tintern Abbey, the still sad music of humanity becomes audible, echoing among the traces of the past to catch the poet's attention. This is, one might say, an anti-nostalgic or even anti-antiquarian mode of relating to ruins. The poet knows that nothing can "bring back the hour/Of splendor in the grass." Ruins—of people as well as buildings—tell him that. But they also tell him, "We will grieve not, rather find/Strength in what remains behind." The strength of these traces, what remains, is the music—and the poetry—of humanity.[7]

Although admirers of ruins in the eighteenth and nineteenth centuries may have differed in their interpretations of the decay that attracted them—a warning against earthly ambition or a promise of natural harmony—they had in common a sense that objects became ruins through the inexorable march of time. And the march of time was slow, which allowed for decline, not just destruction. As the eighteenth-century travel writer William Gilpin put it: "A ruin is a sacred thing. Rooted for ages in the soil; assimilated to it; and becoming, as it were, part of it; we consider it as a work of nature, rather than of art."[8] There are, however, other kinds of ruins, among them buildings thrown into disrepair through some violent natural force, the terrifying power of which is overwhelming. The "theater" produced by Martin Engelbrecht in the late 1750s, which most likely represents the Lisbon earthquake, is a curious depiction of this power. The viewer peers through an aperture in a series of cards, each of which portrays aspects of the earthquake and its victims, to see a three-dimensional rendering of the event (p. 45). The scene of chaos and devastation is brilliantly colored. A blue tower with a bright red roof breaks and falls over, animals run about in terror, a horse rears up; men, women, and children with arms raised in panic try to escape as all around them blue columns buckle and red stone buildings collapse.

On the morning of All Saints' Day, 1 November 1755, three separate shocks rocked Lisbon, immediately creating ruins and enveloping them in a cloud of dust. The destruction of Lisbon was a forceful reminder to European intellectuals that their ideas of progress were dependent on a picture of nature as stable. If History, in contradistinction to Nature, was progressive, that was because people could work their environment into a home for themselves; they could break from the cycles in which other animals lived to create a developing culture that would allow for successive generations to build upon each other. The Lisbon earthquake's extraordinary destructive force—combined with the ensuing fire, which forced a massive exodus of survivors—demonstrated just how dependent culture was on the cooperation of nature.[9]

It is one thing to aestheticize the gradual decay of monumental buildings, another to aestheticize the effects of disaster. Yet the Engelbrecht theater remains an attractive object for many of us, despite its depiction of extraordinary pain and suffering. Surely this has something to do with the age of the object and our historical distance from the event. For us, the theater itself is a kind of ruin, a fragile trace of another way of representing and peering at the world. And yet the remains of destruction, even rapid, terrifying destruction,

seem to exert an eerie fascination, to offer unexpected pleasures. Spectators who looked through Engelbrecht's construction in the eighteenth century would probably have concentrated more on the content of what they saw than on the viewing device itself. Would this have reduced the pleasure they found in this little theater or increased it? Violent destruction can appear, as Chateaubriand put it, "like gray hairs on the head of a youth."[10] Premature ruins, as one may call them, can exert an uncanny effect. But how distant in time need they be for us to *enjoy* them and to discuss this enjoyment in public? The postcards in the exhibition, some of which are reproduced in this catalog (pp. 54–57), are in a sense a more contemporary version of the Lisbon theater. The postcard craze in early twentieth-century America was stimulated by Kodak's introduction of roll film and the promotion of the idea that one could turn one's pictures into missives. In these postcards, highlighting classical motifs or allowing for a group portrait amidst the wreckage, the destruction caused by California earthquakes was "seen-to-be-sent." The might of unruly nature is awesome, but its effects can be reclaimed in patterns of framing established by earlier traditions of depicting (and thus relating to) ruins. Today, the little theaters of our television sets and the missives of the Internet allow us to encounter "premature ruins" at almost every turn. Perhaps it is too soon to understand how these media will affect the ways we relate to ruins or the extent to which we take pleasure in destruction—even without any temporal distance, and even in public.

Where the first section of the exhibition emphasizes how objects are framed as ruins, the second section, "Recycling, Reconstruction, and Preservation," underlines how objects so framed have been further used or treated. Clearly, there is a great deal of overlap between these sections because to frame an old building or an old body as a ruin is already to *do* something to (with) the object. This frame means, among other things, that the object conveys something essential about the past and the passage of time. The second section emphasizes some of the important consequences of this framing. Some commentators have perceived it as necessary, for example, that an ancient building be separated in some way from daily use so that its pastness could be more dramatically made manifest. Seen from this vantage, it becomes important that the ruin appear as an anachronism: as a message from the past more than as an active site of life in the present. As a consequence, the trace of the past, even if it could not be fully detached from the fabric of a new culture, was placed into a kind of convalescence as a ruin—if only to protect it from further decay. As the art historian Alois Riegl noted in an essay of 1903, "Only works for which we have no use can be enjoyed exclusively from the standpoint of age-value, while those which are still useful impede such pure contemplation."[11] The paradoxical attempt to preserve a site *in its decay* is part of our acknowledgment that we are called by the past even as we recognize that we can have no full knowledge of it. A site that could provide full

access to the past would no longer be a ruin since it would have lost nothing over time. But a site that carried with it nothing of the past would no longer seem a ruin of something else, evidence of another time that reminded us of our own existence as mortal beings who can remember and be remembered in turn.[12]

The call of the past can, of course, be translated in various ways and made to carry many messages. And the convalescence of an artifact—its separation from contemporary life—can be short-lived when pressed into some new use within the context of religion, politics, or aesthetics. "Age-value" can come to validate or protect contemporary social practices. We can see this in concrete form in the sixteenth-century engraving of the Pasquino sculpture (fig. 5). Beginning in the late fifteenth or early sixteenth century, the Pasquino was used by Romans as a vehicle for criticism, gossip, and wit. Disgruntled citizens would post messages near the statue or hang placards with their complaints or *bons mots* on it. These messages of protest and mockery were often directed at specific individuals—popes, cardinals, condottieri—and the ruined statue came to function as an authorizer of even very salacious censure. The plinth on which the Pasquino sits in the engraving bears an inscription, which reads in part:

> But I am that famous Pasquino
> Who makes the great lords tremble
> And astonishes foreigners and countrymen
> When I compose in vernacular or Latin.

The Pasquino was felt to be such an annoyance by those in power that one ruler, it has been said, actually plotted to dump it into the Tiber. The tradition of the "talking statue" was launched, however, and a decayed and broken sculpture was able to communicate sentiments that ordinary people were afraid to express openly. The lampoons became known as *pasquinades,* a term that is still employed to refer to satirical messages, especially those posted in public spaces. With the application of this word, the tradition of protest and mockery is made to reveal a trace of the symbolic protection that it once received from a ruined survivor of the distant past. Past and present coexist in easy anachronism.[13]

If the Pasquino image exemplifies the ways that ruins might be used within the fabric of early modern civic life, the frontispiece to the Comte de Caylus's *Recueil d'antiquités égyptiennes, étrusques, grecques et romaines,* 1752–1767, frames the past as something that is buried, hidden but still accessible to those with the proper tools (fig. 6). The classically clad workmen, true heirs of the distant past that they strive to uncover, must contend with a history that has been buried by nature, not simply overgrown with vegetation. This image comes at the end of a great tradition of amateur antiquarianism and points forward to the development of archaeology as a discipline, to the organized, scientific effort to *unearth* the past that we casually tread upon.

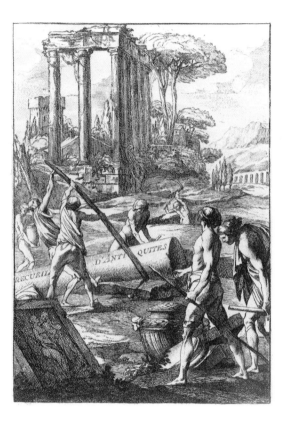

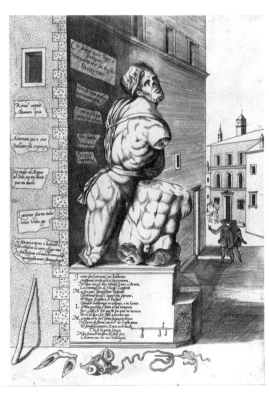

Fig. 5. Nicolas Béatrizet (?), "Pasquino" sculpture in Rome, engraving from *Speculum romanae magnificentiae*, 1544(?)–1602. Los Angeles, The Getty Research Institute for the History of Art and the Humanities, acc. 91-F104.

Fig. 6. Anonymous, excavation of architectural fragments in a classical landscape, engraved frontispiece from *Recueil d'antiquités égyptiennes, étrusques, grecques et romaines*, 1752–1767. Los Angeles, The Getty Research Institute for the History of Art and the Humanities, acc. 92-B25956.

With this development came the assumption that antiquity could be *made* to appear to us as an object of study as well as contemplation.

Earlier, in the Middle Ages, unearthed ruins were often recycled or employed to establish the relationship of Christian civilization to its pagan Roman predecessor. Ruins in this context were used to show that the new order was built on the fragments of a world that had become an object of emulation, if not rivalry. As Salvatore Settis has noted about the Medieval period,

> The breaking up of a city or monument certainly implies a loss of meaning and its replacement by another, new meaning ("the end of paganism"), but in order for this new meaning to manifest itself distinctly, the grandeur — or claritas — of the original meaning must somehow be perceived.[14]

If the investigation of a loss of meaning in the Medieval period took place in the context of Christianity, in the eighteenth century a search for original meaning was secularized, and being trained in modes of research and argument lent individuals legitimacy in deciphering the significance of the past in relation to the present. Once the fragments of the past were uncovered, it was assumed that the trained archaeologist could piece them together and even rebuild the past. Ruins had become the object of science, not faith, and they offered crucial evidence in the effort to understand not the workings of a providential plan of Redemption, but instead the history of great civilizations.[15] The image of the interior of the Temple of Diana at Nîmes from Charles-Louis Clérisseau's *Antiquités de la France*, 1804, illustrates that knowledge gained from a study of ruins was thought to have been useful for artists or architects working in the present (fig. 7).[16] The knowledge of the ancient builder was not esoteric but technical, and it could be appropriated just as monks once appropriated spolia from ruined Roman temples in order to connect their own orders to the glory of the ancient city.

At the end of the second section of the exhibition, we once again encounter ruins created by cataclysmic events, though in this instance the events were not natural in origin but political. These premature ruins had their own uses. Throughout the antebellum period, American artists and writers had imagined ruins in a Romantic vein. With the outbreak of the Civil War and the advent of new techniques of photography that were available to document it, there arose the possibility of picturing devastation quickly and communicating it to a wide audience. Through photographs, those living away from the battlefields were given a sense of the war's devastation. Photographers and artists who pictured the ruins of war, however, often had propagandistic intentions. Thus, in 1865 George N. Barnard depicted Southern forces as fanatical and antimodern, willing even to destroy their own city of Charleston rather than leave it to the victorious Union soldiers (see p. 27). More generally, photographic images of the war became temporary monuments commemorating sacrifices of soldiers who fought and died in unprecedented numbers. Photographs were sites of memory that had to be integrated

Fig. 7. Charles-Louis Clérisseau, interior of the Temple
of Diana at Nîmes, France, engraving from *Antiquités de la
France*, 1804. Los Angeles, The Getty Research Institute
for the History of Art and the Humanities, acc. 88·B2179.

into a new sense of what it meant to be an American and to live with a past that very suddenly contained ruins: ruins of buildings, of whole cities, and of hopes for a more perfect, peaceful, and glorious union free from the ravages that had afflicted European history. The scars of the Civil War were kept visible in official ruins and dramatic photographs that would be used for a variety of political purposes in both the North and South after they were rejoined in uneasy union. For the South, ruins were to be signs of the struggle for a lost cause, signs that would provoke nostalgia for many whites who resisted accepting modern industrial life. For the North, ruins were to be a reminder of the sacrifices made to preserve a political union founded on basic principles, never to be forgotten.

Just as the American Civil War was an event in which devastation and photography were conjoined to create new conditions for framing ruins, so the Paris Commune allowed for the linkage of violent destruction and detailed documentation. At the end of the Franco-Prussian War in 1871, the citizens of Paris refused to agree to a surrender and took over the city. Photography played a complex role in this violent upheaval. It was used by the revolutionaries to document the overturning of what they hoped would be another Ancien Régime, as in the Bruno Braquehais photograph of the demolition of the Vendôme column (fig. 8); but after order was restored the same images often found their way into the hands of the police eager to identify Communards for arrest and prosecution.[17] Making a ruin was dangerous business.

With the defeat of the Commune there came a flood of anti-Commune photographs, some using the new medium to recreate scenes of the "crimes" that the revolutionaries had committed in the final, bloody days of the conflict. Unlike even the most realistic of politically charged paintings, these photographs carried with them an implicit, but often completely unwarranted, claim of veridical representation. The photographer Eugène Appert, for example, had missed the actual events, and so he staged models of executions that he would then "document" with his camera. Others rushed into the streets with their equipment to frame the city in ruins even while the buildings still burned. As the photographer Justin Lallier put it, "The sad memory of the Commune was still living and our monuments still smoking when the publisher, P. Loubère, had the ingenious idea to consecrate the bloody wounds of our great Paris in a collection of twenty photographs."[18] Photography framed the destruction of buildings as the creation of ruins. This was not the steady growth of nature or even the arbitrary shock of an earthquake. Convulsive revolution and repression created ruins for the beholder. But how was one to contemplate them? How was one to use them?

In the Commune photographs of Braquehais and Alphonse Liebert (figs. 8, 9, and pp. 62–63), one can see the aesthetics associated with the representation of ancient stones combined with the new powers of photographic documentation. The columns and the archways in Braquehais's photograph of the ruins of the Tuileries Palace suggest ruins of ancient buildings, while

Roth

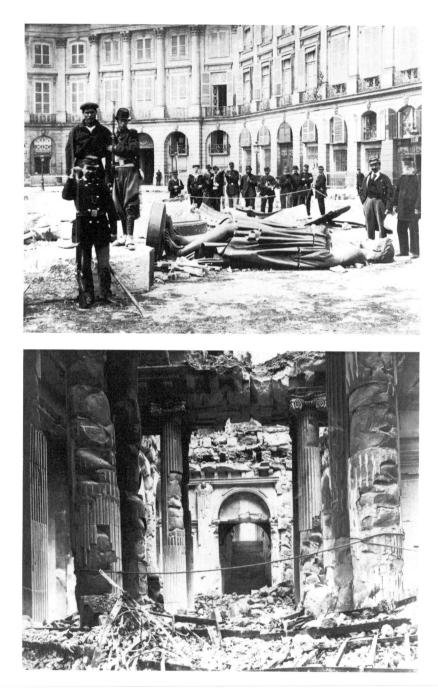

Fig. 8. Bruno Braquehais, demolition of Vendôme Column,
Paris, 1871, albumen print. Los Angeles, The Getty
Research Institute for the History of Art and the
Humanities, acc. 95.R.102.

Fig. 9. Bruno Braquehais, ruins of Tuileries Palace, Paris,
1871, albumen print. Los Angeles, The Getty Research
Institute for the History of Art and the Humanities,
95.R.102.

the debris in the foreground with the rope extending across the middle of the image points us toward the recent disturbances. History, not nature, has overwhelmed these stones. The Tuileries and the Hôtel de Ville were surely *en ruine,* but what kind of ruins were they? Did they present a conservative message about the horrors of revolution and the dangers of political activity by the masses, or did they serve to recall to these same masses the power they could assume when they took charge of their own destiny? Just as the ruins of the Lisbon earthquake had demonstrated to eighteenth-century intellectuals that progress depended on the cooperation of nature, the ruins of the Paris Commune made clear that progress was dependent on the cooperation of people who felt left behind by the development of bourgeois society. The conflicts over the meaning of the ruins of the Commune remained a significant facet of political life in France during the early Third Republic. It was a dozen years before the government made up its mind to destroy the monument to destruction that was the Tuileries and to restore it only as a purely historical building whose messages were to be confined to lessons about the past rather than future political possibilities.[19] The remarkable photographs of the Commune remain as emblems of ruins with which it proved too difficult to live.

Ruins were thus used as scenes of moral instruction, or admonition, in the wake of violent conflicts. This convention grew more intense after World War I, when the graveyard was to function as a somber reminder of the destructive power of mechanized warfare. And again after World War II, ruined buildings such as Berlin's Kaiser Wilhelm Gedächtniskirche and Dresden's Frauenkirche were to serve as "perpetual" warnings against militarism. Four years after the end of World War I, Albert Einstein's tour of war ruins in France was used as a call for peace. The "most powerful brain in the world" — but not yet a link to the nuclear age — visited the region of Dormans and saw the extraordinary devastation wrought by militarism (fig. 10). The scientist is quoted as saying that all the students in the world should visit these ruins. An encounter with these sites of remembrance might cure people of their "literary" idea of military conflicts and the ruins they cause. Einstein remarked, "If only they could *see!*"[20] He, himself, of course, would see many more ruins in his lifetime. We have yet to learn, however, if such ruins have had any effect on the intoxication with destruction that has so marked modernity.

Section three of the exhibition concerns issues of "Loss, Recuperation, and Identity." Here the focus is on the Western framing of ruins in Latin America and Asia. As Europeans explored various parts of the world, they brought established techniques of framing and representation with them. Having been sent to India in 1857 by the British War Office to document the destruction of monumental buildings, the photographer Felice Beato arrived in Lucknow only to discover that he had come too late to get pictures of the aftermath of an uprising in which the British were said to have slaughtered some two

thousand mutineers. Undaunted, he had the bodies of the rebels strewn about in front of the ruins of the Sikandrah Bagh Palace in order to send "documentation" to an audience that already had strong visual expectations of savage conflict (p. 66). Other European adventurers, scientists, and explorers "discovered" other pasts, traces of histories that did not fit onto any conventional timeline of decline and progress. Was the export of archaeologists, photographers, and historians an attempt to colonize the past of others or was it some more universalistic, humanist effort to understand how Western civilization was related to others around the world? Perhaps these two impulses were closely entwined. Their interconnection makes it very difficult for any particular group to reclaim legitimately cultural patrimony or heritage. To whom does the past belong, and how is it reclaimed? These questions are as potent for the Elgin Marbles, currently in Britain and claimed by Greece, as they are for the temples of Sri Lanka, which remain the object of dispute between the Sinhalese and the Tamils (pp. 68–69).

Thomas Daniell's late eighteenth-century engraving of Hindu excavations recalls contemporary framing of European ruins. The past emerges from the ground of the present, and part of the colonial project is to reclaim that past as an object for cosmopolitan contemplation (p. 65). Decades later, the photographers Urbain Basset and Désiré Charnay traveled from France in search of exotic ruins, of histories that followed rhythms different from those of the European past. But though their voyages took them far, they continued to hear that still, sad music of humanity. One can see in their images the pull between nature and culture that was typical of European representations of decayed buildings—a tension that Simmel would claim was characteristic of all ruins. In Basset's photograph, a decayed building at Angkor (p. 70) stands before us in sad majesty, a witness both to the extraordinary capacity of people to erect intricate, mighty monuments and to the force of nature to engulf those monuments. But it stands before us in this way because it was framed by a French photographer who reclaimed it as a part of *his* culture's tradition of representing and contemplating ruins. When Charnay traveled through Mexico he brought this same tradition with him, and this tradition guided his framing of the ancient native ruins (pp. 27, 71). Captured by his lens, the immense efforts of distant multitudes now appear as universal markings on the landscape to which they once belonged. Who can reclaim these landscapes and the inheritance of these efforts?

Perhaps the universal that these photographers saw through their lenses was simply the triumph of time or nature over culture. But perhaps they also thought that with the modern tool of photography they had acquired a new weapon in the human effort to forestall the effects of time. After all, photography seemed to offer the capacity to stop time in its tracks—or at least the illusion of this capacity. Their pictures, if preserved carefully, might not suffer the fate to which even the mighty buildings succumbed. "Every photograph," wrote Roland Barthes,

is a certificate of presence.... Perhaps we have an invincible resistance to believing in the past, in history, except in the form of myth. The photograph, for the first time, puts an end to this resistance: henceforth the past is as certain as the present, what we see on paper is as certain as what we touch.[21]

By fixing ruins on photographic paper, we don't repair them, but we have the illusion of reclaiming them from the further effects of nature and of time—that is, from death. This illusion is based, in part, on our forgetting that the representations, whether on photographic paper or on canvas, will also age and become with time ruins of another sort. In collecting and caring for these representations, institutions like the Getty Research Institute and publications like this volume attempt to forestall that decay while at the same time documenting earlier efforts to escape it.

Much of the material in this volume and the exhibition is a product of an orientation to the past that seeks to reclaim ruins from time and for representation. The reclaiming has been legitimated by the sciences of history and archaeology, and it has been fueled by an aesthetic sensibility that takes the elusive, fragmentary experience of the past as one of its deepest resources. No one better exemplifies that sensibility than Marcel Proust, whose *A la recherche du temps perdu* can be read as an extended reflection on the accumulation of ruins in a culture, in a life. By naming his Norman town Balbec, a place of pleasure and thereby of longing and loss, he evokes the memory of the ancient city of Baalbek, in present-day Lebanon, a place of the framing and recycling of ruins, of conflicting cultures and desires. "And nothing," he wrote, "could have differed more utterly from the real Balbec than that other Balbec of which I had often dreamed, on stormy days, when the wind was so strong."[22] In naming his treasured town after the desert ruins ("those names now magnetized my desires"),[23] Proust took distance on the past, looking into memory by taking a detour through a foreign object: "Even from the simplest, the most realistic point of view, the countries for which we long occupy, at any given moment, a far larger place in our actual life than the country in which we happen to be."[24] Or perhaps one should say that it is in the encounter with the foreign object that memory opens itself to the author, to us. Famously, for Proust, this encounter cannot be forced; it cannot even be willed. The encounter must depend on detours, accidents that may prompt the past to emerge from the oblivion to which it seems to be consigned.

The better part of our memories exists outside us, in a blatter of rain, in the smell of an unaired room or the first crackling brushwood fire in a cold grate: wherever, in short, we happen upon what our mind, having no use for it, had rejected, the last treasure that the past has in store, the richest, that which, when all our flow of tears seems to have dried at the source, can make us weep again. Outside us? Within us, rather, but hidden from our eyes in an oblivion more or less prolonged. It is thanks to this oblivion alone that we can from time to time recover the person that we were.[25]

The past returns to us only in the rare moments when a constellation of contingencies creates a kind of equipoise, when for some reason (who knows why?) we are given access to—we are overcome with—a time that is not our own. "My journey to Balbec was like the first outing of a convalescent who needed only that to convince him that he was cured."[26] In the engraving of 1799 of Baalbek by Louis-François Cassas (fig. 11), the keystone of the gateway to the Temple of Bacchus (which Cassas referred to as the Temple of Jupiter) seems poised to fall, a sign of the dangerous and fragile equipoise that ruins can find between past and present. But in the nineteenth-century photograph of the same temple at Baalbek by Félix Bonfils (p. 67), we see that the modern desire for the past has come charging to the rescue: *preserving* the keystone by making it impossible for nature to continue its work, in effect, stalling time. The British put in the column of bricks circa 1870, and later the Germans would hoist the keystone back toward its "original position." Should it have been left to fall? To let the "fallen stones" that are ruins fully collapse into decay would be to acquiesce in destruction—to lose the past for fear of disturbing its temporal rhythms. Yet, the intervention of the column of bricks that we see in Bonfils's image reminds one of John Ruskin's point, so important to the author of *A la recherche du temps perdu*, that restoration equals destruction. The balance that makes an object a ruin is destroyed when the edifice is saved.

> Neither by the public, nor by those who have the care of public monuments, is the true meaning of the word *restoration* understood. It means the most total destruction which buildings can suffer: a destruction out of which no remnants can be gathered: a destruction accompanied with fake description of the thing destroyed. Do not let us deceive ourselves in this important matter; it is *impossible,* as impossible to raise the dead, to restore anything that has ever been great or beautiful in architecture.[27]

Proust, too, was torn by the desire to stall time, to recapture it, while at the same time aware that forgetting and destruction were essential aspects of time and any attempt to grasp it. The work of art, the novel, thus becomes a ruin that is never fully restored and not even finished. "What persists, writing recovers in fragments / Write, write write," as Edmond Jabès put it, "in order to remember."[28] Proust's novel, even more than the photograph, preserves the essential ambiguity of the ruin by preserving its fragility as fragment; always about to fall apart but still working for us as a prompt to memory, as a call to and from the past. But does the restoration and understanding even of writing also contain an element of destruction, as Jabès insisted?

Through the intricate delicacy of Proust's narration one feels not only the slow march of time, the triumph of nature and the force of forgetting; one feels also the ways that World War I fragmented European perceptions of the past, while disconnecting it from reasonable hopes for the future. Like the Lisbon earthquake of the eighteenth century and the conflicts of the nineteenth, the

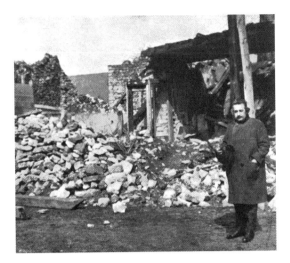

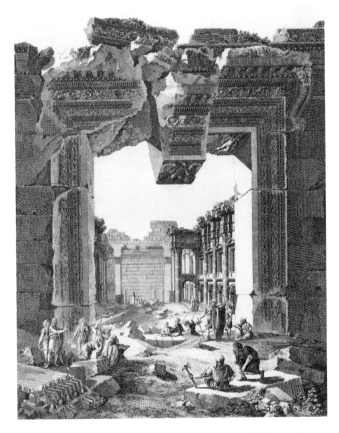

Fig. 10. **Anonymous,** Einstein in the ruins of a village in the region of the Dormans (France), photograph from Charles Nordmann, "Avec Einstein dans les régions dévastées," *L'illustration*, no. 4128 (15 April 1922): 329. Los Angeles, The Getty Research Institute for the History of Art and the Humanities, 84-S259.

Fig. 11. **Louis-François Cassas,** keystone of Temple of Bacchus, Baalbek, Lebanon, unpublished engraving intended for *Voyage pittoresque de la Syrie, de la Phénicie, de la Palestine, et de la Basse Egypte,* 1799. Los Angeles, The Getty Research Institute for the History of Art and the Humanities, acc. 840011*.

total wars of the twentieth century have shaken our framing of ruins and shattered the notion that culture can exist as an innocent, floating fragment in a powerful sea of violence. In the wake of World War II, culture itself came to be cast as a ruin, as a troubled witness to the violence of humanity rather than as a spectator of the sublime powers of nature. The pensive attitude of contemplation staged by Austin Whittlesey in his photograph of a Moroccan minaret, 1916 (fig. 12), seems out of place in a world of mechanized destruction and snapshot representation. Better to view the ruins from afar, as in an aerial photograph, or in the imagined new ruin-building of Lebbeus Woods, torn open now to reveal possibilities of transformation (p. 72). The sentimental attachment to the ruin, the contemplative gaze that finds some sign of renewal in nature's growth on a broken stone, has been shaken, diverted. The promise of understanding the past and of the renewal or even redemption that this understanding might provide seems empty or a lie in the wake of the extremities (and the threat of nuclear annihilation) that turned a world into (potential) ruins. In Paul Celan's poem "There was Earth Inside Them, and They Dug," he asks, "Where did the way lead when it led nowhere?" Or, as Adonis wrote in his "A Mirror for the Twentieth Century":

A coffin bearing the face of a boy
A book
Written on the belly of a crow
A wild beast hidden in a flower

A rock
Breathing with the lungs of a lunatic:
 This is it
 This is the Twentieth Century[29]

The regular rhythms of nature have been replaced in our time by the enormity of our capacity for ruination. How, then, do we reclaim ruins or understand what has been for centuries the irresistible attraction of their decay? This volume and the exhibition that it accompanies cannot hope to answer this question. Instead, they offer fragments from important traditions documenting ways of relating to what is left to us, what remains from cultures overgrown by nature or simply destroyed by violence. These fragments cannot bring us the past, but they can lead us to an understanding of our attitudes about and feelings for what persists, sometimes not too well, in the present.

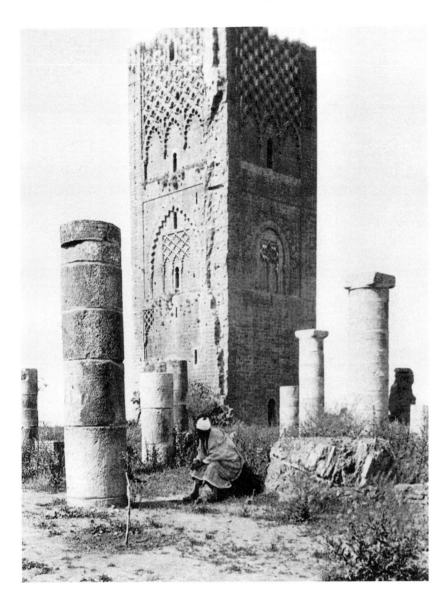

Fig. 12. Austin Cruver Whittlesey, minaret, Hasan
Mosque, Rabat, Morocco, gelatin silver print. Los Angeles,
The Getty Research Institute for the History of Art and the
Humanities, acc. 84.R.1.

Notes

1. On the relations that exist among theater, architecture, "public anatomy," and Estienne's work, see Giovanna Ferrari, "Public Anatomy Lessons and the Carnival: The Anatomy Theatre of Bologna," *Past and Present* 117 (1987): 84–85.

2. See Georg Simmel, "The Ruin," in idem, *Essays on Sociology, Philosophy, and Aesthetics,* ed. Kurt H. Wolf (New York: Harder, 1965), 259–66.

3. Ibid., 262.

4. See, for example, John Wilton-Ely, "Introduction," *Giovanni Battista Piranesi: The Complete Etchings* (San Francisco: Alan Wofsy Fine Arts, 1994), 1: 1–3. The literature on Piranesi and ruins is enormous. See, for example, Georges Brunel, ed., *Piranèse et les Français: Colloque tenu à la Villa Médicis, 12–14 mai 1976* (Rome: Edizioni dell'Elefante, 1978); Andrew Robison, *Piranesi—The Early Architectural Fantasies: A Catalogue Raisonné of the Etchings* (Washington, D.C.: National Gallery of Art; Chicago: Univ. of Chicago Press, 1985).

5. See Paul Zucker, *Fascination of Decay: Ruins, Relic, Symbol, Ornament* (Ridgewood, N.J.: Gregg Press, 1968), 143–45.

6. On the rage for artificial ruins, see Diana Ketcham, *Le Désert de Retz: Le jardin pittoresque de Monsieur de Monville: A Late Eighteenth-Century French Folly Garden* (Cambridge, Mass.: MIT Press, 1994); Günter Hartmann, *Die Ruine im Landschaftsgarten: Ihre Bedeutung für den frühen Historismus und die Landschaftsmalerei der Romantik* (Worms: Werner, 1981); Gwyn Headley and Wim Meulenkamp, *Follies: A National Trust Guide* (London: Cape, 1990); Barbara Mildred Jones, *Follies and Grottoes* (London: Constable, 1974); and Christopher Thacker, "Ruines gothiques: Débris pittoresques ou pierres fondamentales?" in *Jardins et paysages: Le style anglais* (Villeneuve-d'Ascq: Publications de l'Université de Lille III, 1977), 171–82. On this theme, see Lambert Schneider, "Il classico nella cultura postmoderna," in Salvatore Settis, ed., *I Greci: Storia cultura arte società* (Turin: Einaudi, 1996), 707–41.

7. See, in this regard, Stanley Cavell, *In Quest of the Ordinary: Lines of Skepticism and Romanticism* (Chicago: Univ. of Chicago Press, 1988), 74–75.

8. William Gilpin, *Observations on ... the Mountains and Lakes of Cumberland...,* 3rd ed. [1808], 3: 183; quoted in Charles Kostelnick, "Wordsworth, Ruins, and the Aesthetics of Decay: From Surface to Noble Picturesque," *The Wordsworth Circle* 19 (1988): 20–28.

9. For European reactions to the Lisbon earthquake, see, for example, Clarence J. Glacken, *Traces on the Rhodian Shore: Nature and Culture in Western Thought from Ancient Times to the End of the Eighteenth Century* (Berkeley: Univ. of California Press, 1967), 514–15, 520ff; T. D. Kendrick, *The Lisbon Earthquake* (London: Methuen, 1956).

10. Chateaubriand, *Génie du Christianisme* (Paris: Impr. Mignaret, 1803), 153–54.

11. Alois Riegl, "The Modern Cult of Monuments: Its Character and its Origin," trans. Kurt W. Forster and Diane Ghirardo, *Oppositions* 25 (1982): 42.

12. See Paul Zucker, "Ruins—An Aesthetic Hybrid," *Journal of Aesthetics and Art Criticism* 20 (Winter 1961): 119–30.

13. See Francis Haskell and Nicholas Penny, *Taste and the Antique: The Lure of Classical Sculpture, 1500–1900* (New Haven: Yale Univ. Press, 1981), 291–96.

14. Salvatore Settis, ed., *Memoria dell'antico nell'arte italiana* (Turin: Einaudi, 1984–1986), 3: 382.

15. See Alain Schnapp, *The Discovery of the Past* (New York: Abrahams, 1997), passim.

16. On the collection of monuments in this period, see the discussions of Alexandre Lenoir and his Musée des Monuments Français in Francis Haskell, *History and Its Images: Art and the Interpretation of the Past* (New Haven: Yale Univ. Press, 1993), 236–52; and in Stephen Bann, *Romanticism and the Rise of Historical Consciousness* (New York: Twayne, 1995), 145–50.

17. See Jeannene M. Przyblyski, "Moving Pictures: Photography, Narrative and the Paris Commune of 1871," in Leo Charney and Vanessa R. Schwartz, eds., *Cinema and the Invention of Modern Life* (Berkeley: Univ. of California Press, 1995), 253–57; and Donald E. English, *Political Uses of Photography in the Third French Republic, 1871– 1914* (Ann Arbor: UMI Research Press, 1984).

18. For an account of Appert's project, see English (note 17), 32–48; Przyblyski (note 17), 50, 260–74.

19. Claude de Montclos, *La mémoire des ruines: Anthologie des monuments disparus en France* (Paris: Mengès, 1992), 203–7; Kirk Varnedoe, "The Tuileries Museum and the Uses of Art History in the Early Third Republic," in Francis Haskell, ed., *Saloni, gallerie, musei e loro influenza sullo sviluppo dell'arte dei secoli XIX e XX* (Bologna: Cooperativa Libraria Universitaria, 1979), 63–68. There were also paintings of the ruins. See the important discussions of Albert Boime, *Art and the French Commune: Imagining Paris After War and Revolution* (Princeton: Princeton Univ. Press, 1995), 62–64, 112.

20. Charles Nordmann, "Avec Einstein dans les régions dévastées," *L'illustration*, no. 4128 (15 April 1922), 328–31.

21. Roland Barthes, *Camera Lucida: Reflections on Photography,* trans. Richard Howard (New York: Farrar, Straus, and Giroux, 1981), 87–88.

22. Marcel Proust, *Swann's Way,* vol. 1 of *Remembrance of Things Past,* trans. C. K. Scott Moncrieff and Terence Kilmartin (New York: Vintage International, 1981), 416.

23. Ibid., 422.

24. Ibid., 423.

25. Proust, *Within a Budding Grove* (see note 22), 692.

26. Ibid., 693.

27. John Ruskin, "The Lamp of Memory," in idem, *The Genius of John Ruskin,* ed. John D. Rosenberg (Boston: Routledge & Kegan Paul, 1963), 134–35.

28. Edmond Jabbès, "The Desert," trans. R. Waldrop, in Carolyn Forché, ed., *Against Forgetting: Twentieth-Century Poetry of Witness* (New York: Norton, 1993), 534.

29. Adonis is the pseudonym of Ali Ahmad Sai'id. The poem appears in Forché, *Against Forgetting* (see note 28), 561–62. It has been translated from the Arabic by Abdullah al-Udhari. Paul Celan's poem, translated by Michael Hamburger, also appears in this collection (p. 382).

Traces of Loss
Charles Merewether

The disaster ruins everything, all the while leaving
everything intact.

— Maurice Blanchot

R uins remain. They persist, whether beneath the ground or above. In
remaining, they are always already of the past, yet given to the future.
Ruins collapse temporalities. Landscapes and buildings in ruination, reduced
to abandoned sites, are traces that embody a sense of loss. Ruins hold out an
image of a once glorious present, another time, revealing a place of origin no
longer as it was. Their presence is a sign of that loss and of the impossibility
of overcoming it. They remind us of finitude as both disruption and continu-
ity, of the necessity of living on among ruins.

Perhaps more than any other site, the city of Pompeii in its afterlife is
emblematic of the allure of ruins. Destroyed in the year 79 by the volcanic
eruption of Vesuvius, it was frozen in time, buried beneath layers of pumice
and ash. To walk among its ruins is not only to experience the sensation of
passing back into another time but also to experience the presence of death in
the present. Pompeii captures the transience of time while holding change
and mortality in abeyance; by arresting time, the ruins of the city offer to
life a curious form of immortality. On reading Wilhelm Jensen's novel set
in the city of Pompeii, Sigmund Freud wrote: "What had formerly been the
city of Pompeii assumed an entirely changed appearance, but not a living one;
it now appeared rather to become completely petrified in dead immobility.
Yet out of it stirred a feeling that death was beginning to talk."[1] For Freud,
Jensen's idea of a past locked in the present provided spatial and archaeo-
logical analogies for the procedures of psychoanalysis. The entombed city
represented the suspension of history, and its ruins were a testimony to a past
that had been buried. Psychoanalysis, like archaeological excavation, could
reveal what remained but had become invisible. In a text of 1896, Freud dis-
tinguished the option of leaving ruins from that of excavating them, arguing
that ruins cannot be left alone or preserved intact because "stones speak."
They must be worked upon, worked through.[2] He concluded that only by
digging into the rubble does one reveal the fragments of a larger story or
meaning. Yet, when ruins are uncovered they are irrevocably changed: they
become part of the present.

25

Framing Ruins

Freud's reference to archaeology and ruins was made at a time when photography had already begun to serve to document the archaeological discoveries of the ancient world. The camera was seen as an instrument that could arrest the passage of time: photographs could capture what had come to pass and what remained. Photography's ability to document ruin seemed to function as a compensation for the experience of losing the past. This modern technology made sense of ruins, not so much in Freud's terms of working through the past, but, rather, by framing ruins as something that we know is behind us. Photography offered a cultural patrimony that provided the moral impulse to belief in a future without ruins.

The French government founded the Commission des Monuments Historiques in 1837 and the Heliographic Mission in 1851, both of which were charged with documenting ancient and Medieval monuments. In 1858, the French Ministry of Public Instruction commissioned expeditions to Egypt and Jerusalem, and the photographer Désiré Charnay was given a commission to record the ancient monuments of the Mayan civilization in Mexico. Arriving in the midst of the Mexican War of Reform, Charnay waited for five months in Oaxaca for his photographic supplies and baggage to arrive. In March 1859, he made his way to the Mixtec site at Mitla, which dates from A.D. 800–1200.

For the next two years, Charnay photographed Mitla and the other principal Mesoamerican sites throughout Mexico. The photographs provide the viewer not only with an extraordinary sense of the architectural construction and detail of design of each building but also with an overwhelming sense of their destruction. They offer a melancholy spectacle of a culture that had returned to the primeval world of nature. The photographs were presented to the French public with a supplementary text by Eugène Viollet-le-Duc, an official government architect under Napoleon III and a central figure in the revival of interest in Gothic cathedrals and ruins as a material analogue to a view of the world as transient and fragmentary. The photograph of the "Second Palace" at Mitla (fig. 1) reveals little but the remaining rubble of the structure. Two indigenous men sit beside the ruins, placed there by Charnay to provide a sense of the scale of the buildings, yet their portrayal suggests that they belong to another time, a time before the ruins. It is perhaps the power of this past, the idea that a historical memory was embedded in the ruins, that accounts for Charnay's observation that "the Indians steadfastly refused to spend the night in the ruins; the very idea inspired in them a mortal fear."[3]

By 1863, the year Charnay's book *Cités et ruines américaines* appeared in Paris, the project, which until then had seemed to be conceived within the notion of a universal cultural patrimony, had taken on another meaning. While the United States was embroiled in its Civil War, Mexican Conservatives had called for foreign assistance in their war against the Liberals, and France had seen an opportunity to collect its debt from Mexico and realize its ambitions to establish a foothold in the Americas. Napoleon III saw France's

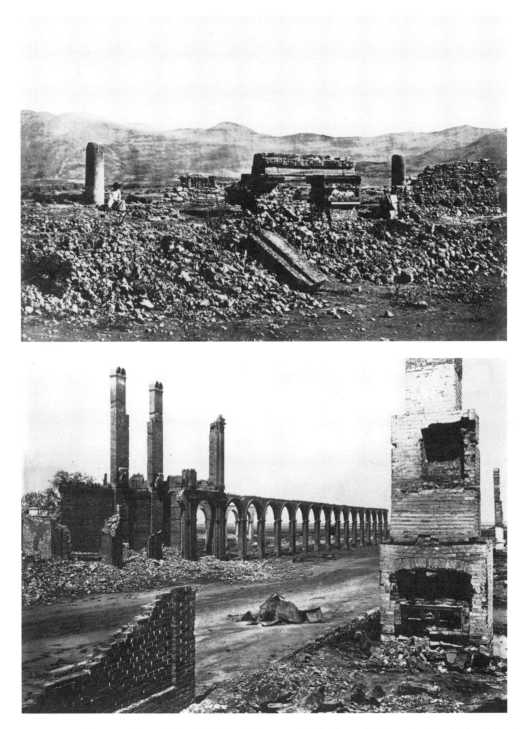

Fig. 1. **Désiré Charnay,** "Second Palace" at Mitla, Mexico, ca. 1859, albumen print. Los Angeles, The Getty Research Institute for the History of Art and the Humanities, acc. 95.R.126*.

Fig. 2. **George N. Barnard,** ruins of railroad depot, Charleston, South Carolina, albumen print from *Photographic Views of Sherman's Campaign*, 1869. Los Angeles: J. Paul Getty Museum: 84.XO.1323.61.

intervention in Mexican affairs as a way of counteracting the interests of the United States in the region by establishing a vital link to what the Europeans conceived of as "Latin America." By 1864 the French government had installed the Austrian prince Maximilian as Emperor of Mexico, an act that Charnay supported.[4] "It was France's duty to rouse Mexico from its numbness," he wrote. "America will not protest: crushed by the horrible war that devours it, reduced to impotence by the probable recognition of the South, she will only be able to watch with a jealous eye the rebirth of the magnificent empire which escaped her."[5]

Although Charnay's photographs of ruins suggest that they existed in an archaic world far away from contemporary times, his observations offer insight into the relation of contemporary events and theories of culture to the framing of ruins. Charnay, following Gobineau's theory of race as proposed in *Essai sur l'inégalité des races humaines* (1853–1855), believed Mexicans to be an inferior indigenous race and a people of the past. He incorporated into his book drawings of these people that compare the physiognomy of their faces with those carved on the monuments. In this respect, the work of Charnay represents an apologist view for intervention in the affairs of the Mexicans. For France, the ruins symbolized the failure of the Mexican culture to become a modern nation, an attitude that legitimated the French Empire's mission to bring Mexico into modern history. And yet, the photographs retain a sense of nostalgia, as if imbued with a longing to return to a time before the ruins. As Charnay noted of these ruins, "this abandon, this silence, this solitude…gives you an unspeakable sadness." This is what Renato Rosaldo has called "imperialist nostalgia," which "uses a pose of innocent yearning both to capture people's imagination and to conceal its complicity with often brutal domination."[6] Photographs became the instrument of colonialism and the tomb of history.

Ruins of Disaster

Ruins contain the traces of former worlds and therefore provoke a certain nostalgia, but living with ruins can also be a reminder of disaster. Photographic albums produced during the American Civil War record the ruins of conflict and devastation, suggesting to us how modern culture was becoming a culture of ruins.

There is nothing elegiac or picturesque about the framing of ruins in George N. Barnard's album of the ruins in the American South, *Photographic Views of Sherman's Campaign* (1869). These photographs offered, rather, a moral lesson to their nineteenth-century audience, as evinced by the legend for an engraving based on one of Barnard's photographs that was published in *Harper's Weekly*: "The destruction intended for others fell with an intolerable weight upon itself."[7] Barnard, an army photographer, arrived in Charleston in March 1865, a time when the city was occupied by Union forces and a "'handful of poor unkempt whites and wandering negroes.' These forlorn residents foraged in streets littered with papers, broken glass, bricks, and other

debris from innumerable burned and damaged buildings."[8] Charleston had been damaged by a great fire in December 1861 and again by bombardment and fire during the Union Army's occupation in early 1865. A newspaper correspondent who visited Charleston in that year wrote:

> A city of ruins, of desolation, of vacant houses, of widowed women, of rotting wharves, of deserted warehouses, of weed-wild gardens, of miles of grass-grown streets, of acres of pitiful and voiceful barrenness — that is Charleston, wherein Rebellion loftily reared its head five years ago.[9]

In photographing the city's ruins, Barnard chose carefully. One of his photographs, which shows a Charleston railway site that had been destroyed by retreating Southern troops, recalls the ruins of ancient Greece and Rome (fig. 2).[10] Such a reference could be made because at this time the archaeological discoveries of ancient cities and sites were being recorded photographically. In the same year, 1865, Tayler Lewis published his book *State Rights: A Photograph from the Ruins of Ancient Greece,* in which he made a defense of the Union cause by recalling the fate of Greek civilization. In comparing the Civil War to the age of antiquity, he wrote that "God has given us a mirror in the past" that reveals that "all the dire calamities of Greece" were rooted in the selfish desire of individual states for autonomy.[11] Barnard's photographs of the ruins of Charleston were not picturesque; the ruins they depicted were not objects of veneration. On the contrary, his images told a cautionary tale intended as a corrective to nineteenth-century guidebooks of classical antiquity. Ruins were framed as warning.

Susan Buck-Morss has suggested in an analysis of Walter Benjamin's writings about ruins and history that

> the debris of industrial culture teaches us not the necessity of submitting to historical catastrophe, but the fragility of the social order that tells us this catastrophe is necessary. The crumbling of the monuments that were built to signify the immortality of civilization becomes proof, rather, of its transiency.[12]

Photography is a technology that strives to overcome this transiency through documentation. Yet modern technology has enabled the destructive capabilities of modern warfare, which can effectively erase the very objects that photography tries to document. Edward Steichen's work from World War I made use of photographic techniques that had been adapted for military intelligence. During the war aerial photographs were used to pinpoint strategic bombing sites as well as record the destruction of cities.[13] Such photographs are both an instrument of war and a witness to its effects (fig. 3). The illusion of veridical documentation and the ideological function of instrumental and aesthetic realism create a blind spot, obscuring the complicity of technologies of representation in technologies of destruction. Photography not only documents destruction, it frames and re-presents its subjects in order to create a

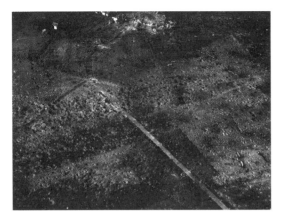

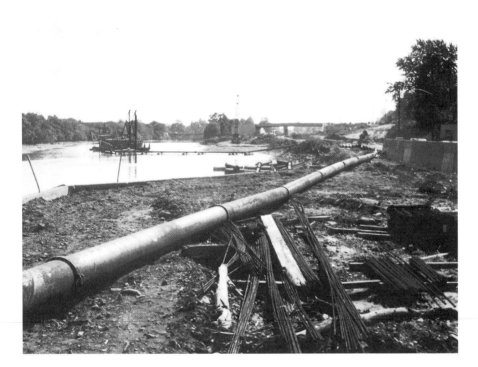

Fig. 3. Edward Steichen, aerial view of war damage, 1914–1918, gelatin silver print. Los Angeles: J. Paul Getty Museum: 84.XM.848.9.

Fig. 4. Robert Smithson, "The Great Pipes Monument," from *Monuments of Passaic*, 1967, gelatin silver print. Courtesy John Weber Gallery, New York.

distance between beholders and the events to which the photographs bear witness. In such work photography produces a new aesthetics of surveillance and domination, an aesthetics that values as compelling what modern science and technology can bring to our comprehension of the world, even as they radically threaten it.

In the work of the North American artist Robert Smithson, this view of technology is posed as a critical issue of artistic representation. "Incidents of Mirror-Travel in the Yucatan" insists that art and photography fail in the face of the Mayan jungle. Aware of those, like Charnay, who had toured and written about the Mayan ruins before him, Smithson ironically employed the format of the travelogue for his artwork of image and text.[14] He writes of looking at photographs of Mayan temples, noting that

> the load of actual, on-the-spot perception is drained away into banal appreciation. The ghostly photographic remains are sapped memories, a mock reality of decomposition.... Art brings sight to a halt, but that halt has a way of unraveling itself. All the reflections expired into the thickets of Yaxchilan.[15]

Smithson's response to this landscape was to place in the jungle a series of mirrors whose reflection displaced the subject, projecting it as elsewhere. He refers to the camera as a "portable tomb," as if to suggest that its function is to capture the subject so that its future is buried in the destiny of the image. Technologies of loss and death haunt the work of Smithson. "Incidents of Mirror-Travel in the Yucatan" is not about Mexico or Mayan culture but rather, as the artist might say, about the ruin-producing effect of modern culture. Smithson's work points to photography's participation in a culture of destruction rather than to its redemptive potential.

In a 1967 essay, Smithson recounts his journey to view the monuments of Passaic, New Jersey. He boards a bus at New York's Port Authority, opens *Earthworks* by Brian Aldiss, and reads the first line: "The dead man drifted along in the breeze." This beginning frames the observations recorded in "A Tour of the Monuments of Passaic, New Jersey," which recall the newpaper correspondent's description of Charleston as a barren city of ruins. Smithson's tour leads him not to venerable monuments of the distant past but to an industrial wasteland of desolate, forlorn monuments, such as a pumping derrick, drainage pipes (fig. 4), a parking lot, and a bridge he names "Monument of Dislocated Directions."

> Actually the landscape was no landscape, but ... a kind of self-destroying postcard world of failed immortality and oppressive grandeur. I had been wandering in a moving picture that I couldn't quite picture.... That zero panorama seemed to contain ruins in reverse, that is, all the new construction that would eventually be built. This is the opposite of the "romantic ruin" because the buildings don't fall into ruin after they are built but rather rise into ruin before they are built.[16]

31

Smithson transforms his disenchantment into an allegorical desire to return to ruins as the foundation of history.[17] He is critical not only of the problems caused by the industrial use of the land but also of what he discerned as the complacency of the picturesque, whether it be that of the eighteenth and nineteenth centuries or that of modernism's ongoing investment in the pastoral landscape.

> Memory traces of tranquil gardens as "ideal nature" — jejune Edens that suggest an idea of banal "quality" — persist in popular magazines like *House Beautiful* and *Better Homes and Gardens*. A kind of watered down Victorianism, an elegant notion of industrialism in the woods; all this brings to mind some kind of wasted charm. The decadence of "interior decoration" is full of appeals to "country manners" and liberal-democratic notions of gentry. Many art magazines have gorgeous photographs of artificial industrial ruins (sculpture) on their pages.[18]

For Smithson, such work by his contemporaries transformed the "'gloomy ruins' of aristocracy ... into the 'happy' ruins of the humanist."[19] Against this art, which he saw as championed by the pre-eminent critic of the day, Clement Greenberg, Smithson suggested that "the artist must accept and enter into all of the real problems that confront the ecologist and industrialist. Art ... should work within the processes of actual production and reclamation."[20] "Actual production and reclamation" does not mean documentation, but an assault on those destructive forces that continue to produce contemporary ruins.

The idea that modern culture begins in ruins, or with ruins, is critical to the work of contemporary French artists Anne Poirier and Patrick Poirier. Their work represents a meditation on ruins as the trace of destruction and, like Smithson, they stand directly against the tradition of the picturesque that contemporary art perpetuates by its appropriation of the ruin as an object of melancholy beauty. However, unlike Smithson, they have constructed fictive ruins as a way of marking the space between the memory of ruins and the ruins of memory. This is the space of loss. Anne Poirier remarks:

> Ruins aren't just the signs of melancholy; they are also signs of violent destruction. ... Patrick lost his brother in the bombings, and throughout my childhood I played in the ruins of our neighborhood in Marseilles. Much later, in 1977 and 1978, we lived in Berlin. We had completely forgotten about the war, but as soon as we arrived in Berlin it all came back to us because the city bears the physical traces of war.[21]

The Poiriers drew on this experience to conceive a form of archive in which, through the fictional character of an archaeologist-architect, each work represents an attempt to draw together the fragments and ruins as a way of making sense of the past. The archaeologist-architect becomes an intermediary, like the analyst, in the work of recovering the traces that remain: "It's his way

of explaining the world around him and trying to understand it, because there's no fixed point to steer by anymore, no trustworthy landmark."[22]

In *Memoria Mundi (No. II)* (1990–91, p. 64), the Poiriers present the archives of this fictional archaeologist-architect in a cabinet whose drawers are filled with different objects: a cranium containing an ancient ruined theater, a field notebook. Each object suggests the material evidence of a civilization, yet the archive is incomplete, and the notebook contains no clue that would allow one to situate the objects' precise place of origin in space or time. The archive turns out to be nothing more than a collection of fragments presented not as ruins of the past but as the ruin of memory.

Neither Restoration nor Erasure

In memory of the events of World War II, Blanchot wrote, "We are on the edge of disaster without being able to situate it in the future: it is rather always already past, and yet we are on the edge or under the threat."[23] Ruins are a legacy that can be neither fully remembered nor fully forgotten; they point to the excessive presentness of disaster, its capacity to spill out of the present into our sense of the past and our expectations for the future. Arrested in time and place, the ruins of disaster are overwhelmingly defined by time and place, yet they are also out of time and out of place.

The architectural work of Daniel Libeskind and Lebbeus Woods has extended into new dimensions the metaphor of ruins suggested by Freud. Both are concerned, like Freud, with excavation because they think that the past cannot be erased, and that to build over the place of ruins would be a suppression and denial of what has come to pass. Their work refutes the domestication of violence and the obliteration of history, seeking to frame what is missing—a void or the space of loss. Libeskind and Woods use ruins to oppose those who propose their restoration to a former glory or infamy and those who argue that since one can never restore what has been lost, ruins must be either erased or recycled.[24]

In the architectural practice of Libeskind and Woods this opposition may be perceived as a negative form of monument, an anti-monument that seeks to expose the history by which it has been produced. As such, their work stands against the building of commemorative structures to memorialize what has been lost, such as Nathan Rapoport's 1948 Warsaw Ghetto Monument, which features a massive bronze relief. Rapoport's monument, typical of those built in the period following World War II, was constructed at the site of the Warsaw Ghetto Uprising of 1943, a site where more than 50,000 Jews were either captured or shot.[25] In contrast to this heroic depiction of resistance, the negative monument is not an object with which people can identify, it is not a commemorative form that fills in a gaping hole produced by the events of history. Instead, a negative monument makes a place for the ruins that remain; it allows them to become an anguished site of cultural patrimony, a site that keeps alive a sense of something at the threshold between the impossibility of remembering and the necessity of forgetting. The ruin

forms a relation to the past; those that view the ruins are exposed to absence, to that which is missing. Although ruins stand for an ethical acknowledgment of that which has been, they nonetheless remain and therefore must not be denied. Framing ruins as an anti-monument is not only a way of addressing the past, it produces a legacy that offers itself as a suspended fragment.

In several projects Libeskind proposes a critical alternative to modernist architecture, one that "navigates between this Scylla and Charybdis of nostalgic historicism on the one hand, and of the *tabula rasa* of a totalitarian kind of thinking on the other."[26] Against these two forms of architectural resolution of ruins, Libeskind seeks "to create a different architecture for a time which would reflect an understanding of history after world catastrophe."[27] In 1989 Libeskind was awarded the commission to build the "Extension of the Berlin Museum with the Jewish Museum Department," which would house collections relating to Jewish history and culture (fig. 5). He proposed an extension, now under construction, that is visibly separate from the existing building, since, for Libeskind, the Holocaust was "an event across which no connection of an obvious kind can ever be made again."[28]

The extension is composed of several independent structures placed around an underground void, or empty space. The structures are connected by bridges that cross the void. There is no visible connection between the museum and the extension; the three connecting paths are underground. The first path represents "the end of Berlin as we knew it, the apocalyptic void." At the end of the path is the "Holocaust Tower," a windowless structure in which the names of all Berliners who were exterminated are inscribed. The second path leads to a garden with columns filled with earth and vegetation growing downward; it symbolizes exile and emigration as well as the year 1948, the year of Israel's formation. The third underground path traverses the void by means of a bridge between the extension and the main circulation stairway within the museum. The only access to the void is through the galleries that house sacred objects from the Jewish community of Berlin. Libeskind explains:

> The void and the invisible are the structural features which I have gathered in this particular space of Berlin and exposed in architecture. The experience of the building is organized around a center which is not to be found in any explicit way because it is not visible. In terms of this museum, what is not visible is the richness of the former Jewish contribution to Berlin. It cannot be found in artifacts because it has been turned to ash. It has physically disappeared. This is part of the exhibit: a museum where no museological functions can actually take place.[29]

What is missing, that which has been lost—this is the void that is the essential core of ruins. Ruins are not necessarily what remains visible. Libeskind takes us to the limits of representation, to the absence of foundation, and to the decomposition of historical time. From this place, Libeskind attempts to bring the history of Berlin together, showing "its evolution, its

Fig. 5. Daniel Libeskind, extension of the Berlin Museum
with the Jewish Museum Department, 1989–1991, archi-
tectural model. Los Angeles, The Getty Research Institute
for the History of Art and the Humanities, acc. 920061.

history, its erasure" and seeking "not to isolate the Jewish history from the history of Berlin...not to turn the Jewish history into some anthropological specimen of an absence."[30]

The Jewish history of Berlin is inseparable from "the history of Modernity, from the destiny of this incineration of history; they are bound together... not through any obvious forms, but rather through negativity; through the absence of meaning of history and an absence of artifacts."[31] The void serves to provoke a realization of memory's absence. It contains no object that is either objectified in some monumental or memorial form or incorporated as a memory of an individual or group. The void seeks to preserve and acknowledge absence and, therefore, to refuse the completion of mourning. Libeskind writes that "the absence, which has been cut off in history, is also the bridge to the future of Berlin. It is through that absence that Berlin goes on."[32]

Lebbeus Woods also argues for an architecture that begins within the context of a culture emptied of meaning. The drawings for the *Berlin Free Zone* project, executed in 1990, just after the dismantling of the Berlin Wall, evoke a sense of a city emptied out or in a state of abandonment (p. 72). The drawings recall those parts of East Berlin that were left in ruins after World War II. By bringing into focus the nature of constructed spaces generally, the images call for a "revaluation of existing cities and societies, as well as the 'use' and 'meaning' of any human life."[33] As aerial views that provide a way of seeing the city in a manner similar to that of surveillance photography, the drawings offer a remarkable visual parallel to aerial reconnaissance photographs. Autonomous forms like airborne missiles appear either to threaten or to fracture and break open the city walls. The grafting of forms over existing structures, however, suggests possibilities for the dynamic transformation of cities and societies. Such change would create what Woods calls "freespaces," which "form the matrix of unpredictable *possibilities* for cultural, social, and political transformation latent in human knowledge and invention."[34]

In 1993 Woods published a manifesto titled *Architecture and War,* written as a proposal for rebuilding the destroyed city of Sarejevo. He argues that while Sarejevo will doubtless rise again, "phoenix-like, out of the ashes," like other destroyed cities, the critical question to be asked is "when they are rebuilt, on what form of knowledge will it be, and to what—and whose— ends?"[35] He notes that "the burning towers of Sarevejo are markers at the end of an age of reasons, if not of reason itself, beyond which lies a domain of almost incomprehensible darkness."[36] For Woods, the destruction of cities and cultures exposes the limits of Enlightenment reason, of a modernity gone awry, and he believes that the project of architecture today is to construct a self-reflexive relation to reason's threat, a relation that recognizes reason's always potential destructiveness. Woods argues that the choice between restoration or erasure is a false one. Restoration is a "reaffirmation of a past social order that ended in war." To replace what has been damaged or destroyed is a "parody, worthy only of the admiration of tourists," serving "the interests of the decrepit hierarchies, struggling to legitimize themselves

finally through sentimentality and nostalgia."[37] And yet, erasure is equally a problem, writes Woods, one imposed by modernist architecture in the name of rationality. Cities are "conceived as *tabula rasa* on which to inscribe new plans," and they are "a totalizing system of space and thought imposed in the name of a common cause."[38] Cities must be (re)built in a way that avoids the temptation of resurrecting the old and beginning with the new.

Thus, like Libeskind, Woods founds his project on living with the power and violence of unreason. He calls for an architecture that will face the fact of war and ruins.

> It is a picture that emerges of its own cruel strength, its disturbing but potentially healing necessity. Only in confronting it can there be any hope of changing its tragic content. Only by facing the insanity of willful destruction can reason begin to believe again in itself.[39]

Willful destruction creates a void, and the recognition of this as an absence is essential to an architecture of the present. Woods views the void like a wound of the body, a wound that can be healed, and the drawings for the Sarevejo project depict architectural surfaces like skin. Over the wound new tissues grow, but the wound leaves behind a scar, the scar of willful destruction. He continues:

> In the spaces voided by destruction, new structures are injected. Complete in themselves, they do not make an exact fit, but exist as spaces within spaces, making no attempt to reconcile the gaps between what is new and old, between two radically different systems of spatial order and of thought.[40]

This site is the place of ruins, and the site of their preservation, where they can remain unforgotten. "The scar," Woods writes, is "a mark of pride, and of honor, both for what has been lost and what has been gained. It cannot be erased."[41] Only on this ground — the incorporation of ruins as a form of memorialization — can the foundations for a different future be built.

The work of Libeskind and Woods, like that of Smithson, makes a politically charged statement about the destructive power of representation. In their architectural designs Libeskind and Woods demarcate a void that is never to have material representation. The void is a figure of their will to recognize absence, to live within the space of loss. The ruined city is part of the patrimony of a culture, and the city itself becomes an archival form constituted from the fragments and shards of memory traces.

Like Freud, Libeskind and Woods realize that any re-presentation of the past is a reworking of it: they refuse to erase or restore ruins. This sets them apart from Charnay and Barnard, who used the documentary power of photography as a way of overcoming a sense of loss. Smithson wished to expose technology's power to perpetuate destruction. As the work of the Poiriers seems to suggest, ruins belong to the archive: the archive of unending disaster,

which "ruins everything, all the while leaving everything intact."[42] Ruins mark the site where the impossibility of remembering and the necessity to forget are both the ground on which history has been founded and the foundation on which to build the future.

Notes

1. Sigmund Freud, *Delusion and Dream, and Other Essays,* ed. Philip Reiff (Boston: Beacon Press, 1956), 175–76. Freud referred to the novel by Wilhelm Jensen, *Gradiva: A Pompeiian Fancy* (1903), trans. Helen M. Downey.

2. Sigmund Freud, *The Aetiology of Hysteria,* in idem, *The Standard Edition of the Complete Psychological Works of Sigmund Freud,* trans. under the editorship of James Strachey (London: Hogarth Press, 1953–1974), 3: 192.

3. Désiré Charnay, *Cités et ruines américanes* (Paris: Gide, 1863), 375; translation by Charles Merewether.

4. Charnay had left Mexico before these events had taken their course. Charnay returned to Mexico in the 1880s to photograph again the Mayan ruins. See Keith F. Davis, *Désiré Charnay: Expeditionary Photographer* (Albuquerque: Univ. of New Mexico Press, 1981), 107.

5. Charnay (see note 3), 202, 203; translation by Charles Merewether.

6. Désiré Charnay, *Les anciennes villes du nouveau monde, voyages d'exploration au Mexique et dans l'Amerique centrale, 1857–1882* (Paris: Hachette, 1885), 189; translation by Charles Merewether. Renato Rosaldo, *Culture and Truth: The Remaking of Social Analysis* (New York: Vintage Books, 1989), 69.

7. Cited in Leo Mazow, *Images of Annihilation: Ruins in Civil War America,* exh. cat. (San Marino: Huntington Library, 1996), unpaginated.

8. "Charleston as It Is," *Syracuse Standard,* 14 March 1865, 3; cited in Keith F. Davis, *George N. Barnard: Photographer of Sherman's Campaign* (Albuquerque: Univ. of New Mexico Press, 1990), 93.

9. Sidney Andrews, *The South since the War; as Shown by Fourteen Weeks of Travel and Observation in Georgia and the Carolinas* (Boston: Ticknor & Fields, 1866); cited in Davis, *George N. Bernard* (see note 8), 93.

10. Davis draws a parallel to Thomas Cole's painting *Roman Campagna* of 1843 and the work of Frederic Church. Ibid., 175.

11. Tayler Lewis, *State Rights: A Photograph from the Ruins of Ancient Greece* (Albany: Weed, Parsons & Company, 1865); cited in Davis, *George N. Barnard* (see note 9), 175.

12. Susan Buck-Morss, *The Dialectics of Seeing: Walter Benjamin and the Arcades Project* (Cambridge, Mass.: MIT Press, 1989), 170.

13. Allan Sekula, "The Instrumental Image: Steichen at War," *Art Forum* 14 (1975): 26–35. The photograph reproduced here is possibly one of the aerial reconnaissance photographs taken under the direction of Steichen in France during World War I by the American Expeditionary Force. Many of the photographs were part of his personal collection. This photograph is attributed to Steichen, but the authorship of the aerial photographs has been disputed, as Sekula notes.

14. Smithson's title makes this explicit by its direct reference to the title of the famous book on Mayan ruins by the traveler-artist John Lloyd Stephens, *Incidents of Travel in Central America, Chiapas, and Yucatan* (New York: Harper & Brothers, 1841).

15. Robert Smithson, "Incidents of Mirror-Travel in the Yucatan" (1969), in idem, *Robert Smithson: The Collected Writings,* ed. Jack Flam (Berkeley: Univ. of California Press, 1996), 127–28, 129.

16. Robert Smithson, "A Tour of the Monuments of Passaic, New Jersey" (1967), in *Robert Smithson* (see note 15), 72.

17. Behind this work was Freud's notion of the compulsive death drive of culture, a view that originated in the wake of World War I and resonated again in the years that followed World War II. Smithson's work was informed by contemporary writings concerning entropy, especially the book *The Hidden Order of Art* by the psychologist Anton Ehrenzweig and the early stories of J. G. Ballard and Thomas Pynchon. Ehrenzweig advanced the theory that culture was always subject to an irreversible condition of entropy, slowly merging back into the landscape. Likewise, both J. G. Ballard and Thomas Pynchon provided Smithson with a visceral description of a modern world of technology that produced an entropic condition of ruination and death. See Anton Ehrenzweig, *The Hidden Order of Art: A Study in the Psychology of Artistic Imagination* (Berkeley: Univ. of California Press, 1967); Thomas Pynchon, *Slow Learner: Early Stories* (Boston: Little, Brown, 1984); and J. G. Ballard, *The Terminal Beach* (London: Penguin Books, 1966).

18. Robert Smithson, "A Sedimentation of the Mind: Earth Projects" (1968), in *Robert Smithson* (see note 15), 105.

19. Ibid.

20. "Proposal 1972" (1972), in *Robert Smithson* (see note 15), 380.

21. Catherine Perret and Alain Bonfand, "Anne and Patrick Poirier, Interviewed," *Galeries Magazine,* April/May 1991: 86.

22. Ibid., 83.

23. Maurice Blanchot, *The Writing of the Disaster,* trans. Ann Smock (Lincoln: Univ. of Nebraska Press, 1986), 1.

24. This is most evident in a project of 1993 by Libeskind for the urbanization of former SS lands in Oranienburg, near Berlin, the site of the first Nazi concentration camp of Sachsenhausen. Libeskind argued against restoring the SS barracks, proposing rather that the facilities become "a place of ruins," allowing them to "slowly fall into decay … into oblivion over time." See Daniel Libeskind, "Traces of the Unborn," *Kenchiku Bunka* 12, vol. 50, no. 59 (1995): 24–28.

25. See James E. Young, "The Biography of a Memorial Icon: Nathan Rapoport's Warsaw Ghetto Monument," *Representations* 26 (1989): 79. Apropos of ruins, a survivor and architect Mark Leon Suzin was commissioned to design and construct the base of the monument in Warsaw. He "decided to incorporate the ruins themselves into the monument base by pouring tons of concrete and reinforcement over them." Ibid., 80.

26. Libeskind, "Traces of the Unborn" (see note 24), 31.

27. Ibid., 44.

28. Ibid., 36.

29. Ibid., 40.

30. Ibid., 38.

31. Daniel Libeskind, *Daniel Libeskind: Countersign* (New York: Rizzoli, 1992), 87.

32. Libeskind, "Traces of the Unborn" (see note 24), 43.

33. Lebbeus Woods, *Anarchitecture: Architecture is a Political Act* (London: Academy Editions, 1992), 17.

34. Ibid., 10.

35. Lebbeus Woods, *War and Architecture*, trans. Aleksandra Wagner (New York: Princeton Architectural Press, 1993), 8.

36. Ibid., 5.

37. Ibid., 10.

38. Ibid.

39. Ibid., 5.

40. Ibid., 21.

41. Ibid., 31.

42. Blanchot (see note 23), 1.

Refinding the Past: Ruins and Responses

Compiled by Michael S. Roth

The finding of an object is in fact a refinding of it.
—Sigmund Freud

If, owing to the work of oblivion, the returning
memory can throw no bridge, form no connecting
link between itself and the present minute, if it
remains in the context of its own place and date,
if it keeps its distance, its isolation in the hollow
of a valley or upon the highest peak of a moun-
tain summit, for this very reason it causes us sud-
denly to breathe a new air, an air which is new
precisely because we have breathed it in the past,
that purer air which the poets have vainly tried
to situate in paradise and which could induce so
profound a sensation of renewal only if it had
been breathed before, since the true paradises are
the paradises that we have lost.
— Marcel Proust

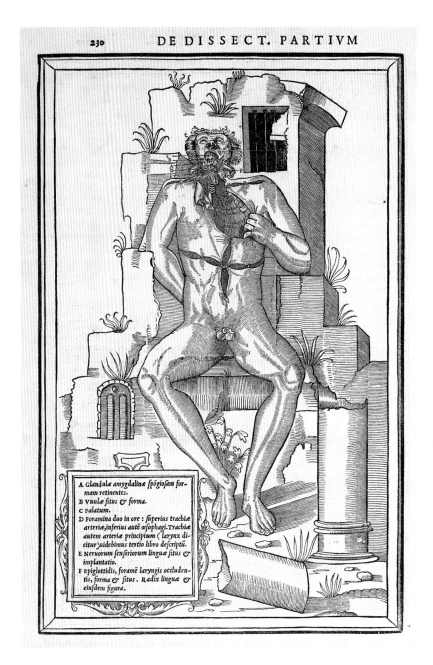

Our life is a fire dampened, or a fire shut up in stone.
— Jacob Boehme

EODEM LOCO.

TER · EXSOMNVS ·
TER · F · AN · VER ·
MIL · LEG · XVI ·
AN · XL · STIP · XVI ·
H · S · E ·

AVRELIVS · DS · P ·

Kingdoms fall, cities perish,
And of what Rome once was
Nothing remains except an empty name.
Only the fame and honor of these things,
Sought out in learned books,
Escape the funeral pyres.
— Florent Schoonhoven

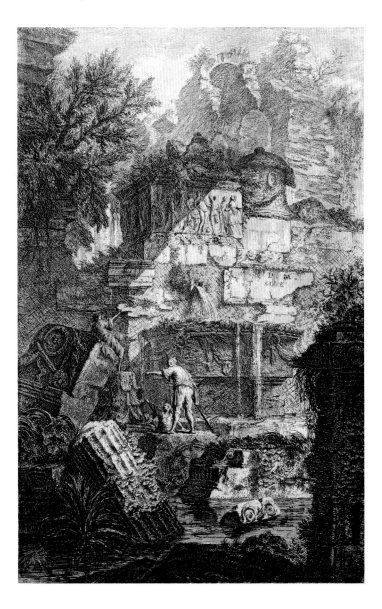

What has led the building upward is human will; what gives it its
present appearance is the brute, downward-dragging, corroding,
crumbling power of nature. Still, so long as we can speak of a ruin
at all and not a mere heap of stones, this power does not sink the
work of man into the formlessness of mere matter. There rises a
new form which, from the standpoint of nature, is entirely mean-
ingful, comprehensible, differentiated. Nature has transformed
the work of art into material for her own expression, as she had
previously served as material for art.

<div style="text-align: right;">— Georg Simmel</div>

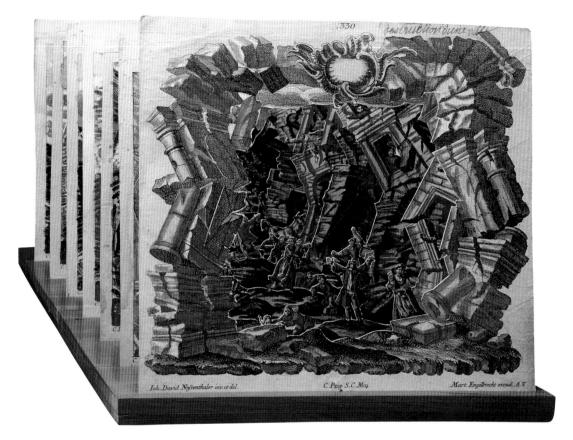

Approach in crowds, and meditate awhile
Yon shattered walls, and view each ruined pile,
Women and children heaped on mountain high,
Limbs crushed which under ponderous marble lie;
Wretches unnumbered in the pangs of death,
Who mangled, torn, and panting for their breath,
Buried beneath the sinking roofs expire,
And end their wretched lives in torments dire.
. . . .
The mind from sad remembrance of the past,
Is with black melancholy overcast;
Sad is the present if no future state,
No blissful retribution mortals wait,
If fate's decrees the thinking being doom
To lose existence in the silent tomb.
All may be well; that hope can man sustain,
All now is well; 'tis an illusion vain.

 — Voltaire

One can read these words carved in marble at Thermopylae:
Passer-by, tell them at Sparta that we died here to obey her holy laws.
It is quite obvious that it was not the Academy of Inscriptions which wrote that.
— Jean-Jacques Rousseau

For, indeed, the greatest glory of a building is not in its stones nor in its gold. Its glory is in its Age, and in that deep sense of voicefulness, of stern watching, of mysterious sympathy, nay, even of approval or condemnation, which we feel in walls that have long been washed by the passing waves of humanity. It is in their lasting witness against men, in their quiet contrast with the transitional character of all things, in the strength which, through the lapse of seasons, and times, and the decline and birth of dynasties, and the changing face of the earth, and of the limits of the sea, maintains its sculptured shapeliness for a time insuperable, connects forgotten and flowing ages with each other, and half constitutes the identity, as it concentrates the sympathy, of nations: it is in the golden stain of time, that we are to look for the real light, and color, and preciousness of architecture; and it is not until a building has assumed this character, till it has been entrusted with fame, and hallowed by the deeds of men, till its walls have been witnesses of suffering, and its pillars rise out of the shadows of death, that its existence, more lasting as it is than that of the natural objects of the world around it, can be gifted with even so much as these possess, of language and of life.

— John Ruskin

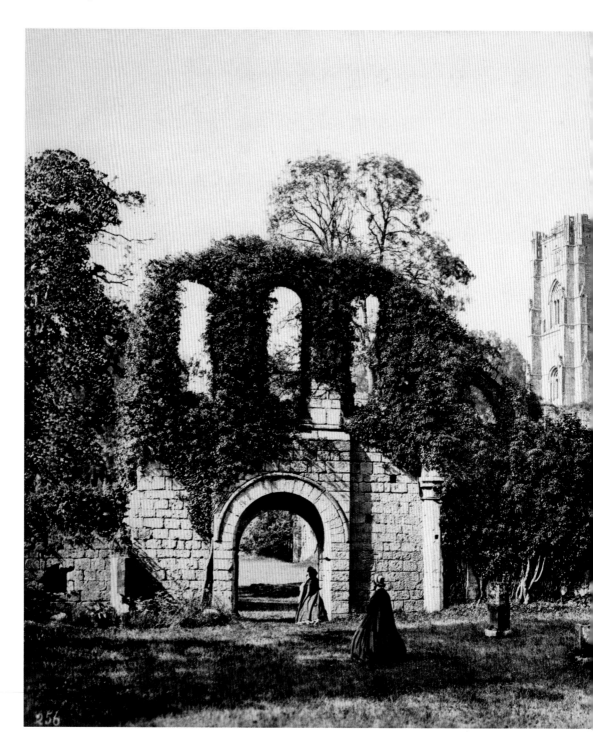

Away with words!
 draw near,
Admire, exult, despise, laugh, weep, — for here
There is such matter for all feeling...
 — Lord Byron

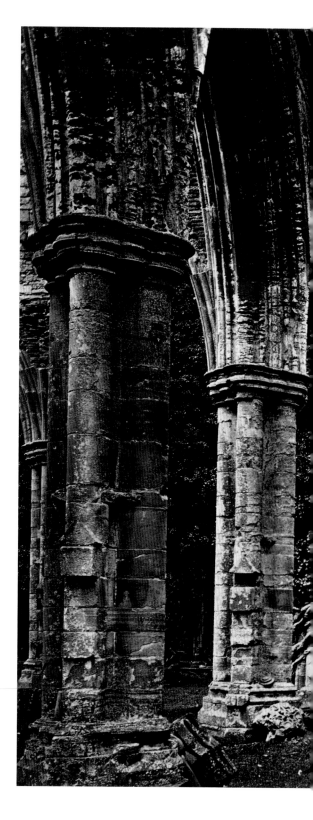

These beauteous forms,
Through a long absence, have not been to me
As is a landscape to a blind man's eye:
But oft, in lonely rooms, and 'mid the din
Of towns and cities, I have owed to them
In hours of weariness, sensations sweet,
Felt in the blood, and felt along the heart;
And passing even into my purer mind,
With tranquil restoration: — feelings too
Of unremembered pleasure: such, perhaps,
As have no slight or trivial influence
On that best portion of a good man's life,
His little, nameless, unremembered, acts
Of Kindness and of love. Nor less, I trust,
To them I may have owed another gift,
Of aspect more sublime; that blessed mood,
In which the burthen of the mystery,
In which the heavy and the weary weight
Of all this unintelligible world,
Is lightened...

 — William Wordsworth

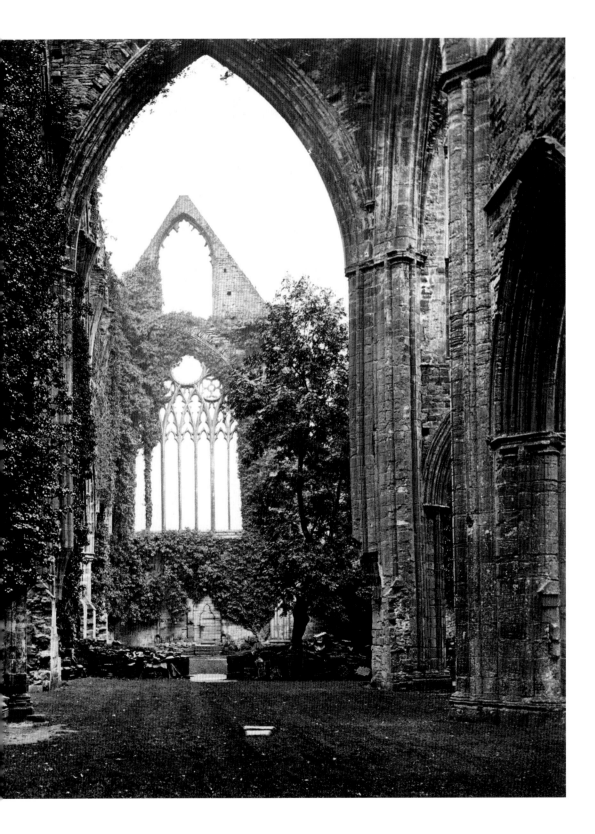

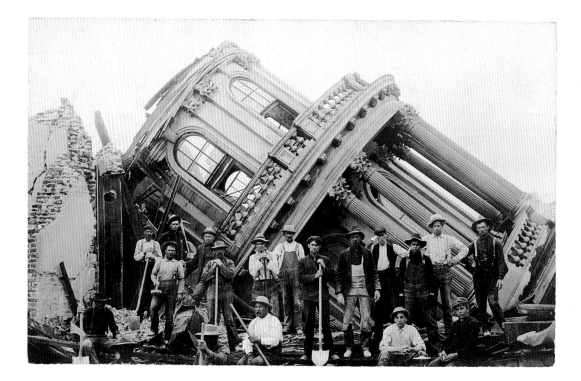

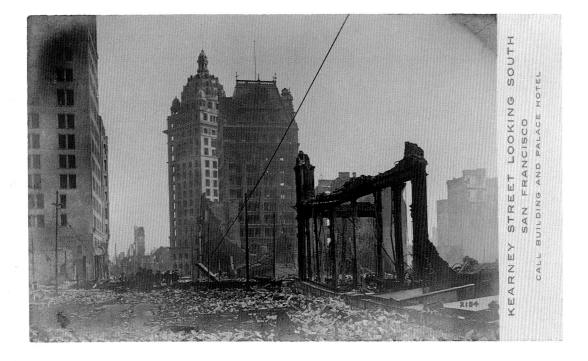

KEARNEY STREET LOOKING SOUTH
SAN FRANCISCO
CALL BUILDING AND PALACE HOTEL

America, you have it better
Than our old continent;
You have no ruined castles
And no primordial stones.
Your soul, your inner life
Remain untroubled by
Useless memory
And wasted strife.
— Johann Wolfgang Goethe

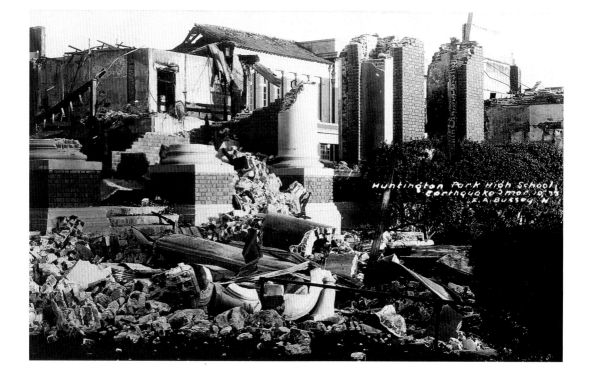

Making earth tremble, as the freezing cold
Will make us shudder and shake, against our will;
And so men tremble in a double fear
Lest houses over their heads come tumbling down
Or caverns, opening under the ground, devour
The mass of ruin. People have the right
To think whatever they please of earth and heaven,
To tell themselves these rest forevermore
On sure foundations, but sometimes it seems
Beliefs like these are undermined more than once,
From more than one direction, and men dread
Lest earth be yanked from under their feet, drop down
Into the bottomless abyss, and all
The sum of things, betrayed, be taken over
In the anarchic ruin of the world.

— Lucretius

On the day the Temple was destroyed the
Messiah was born.

 — Babylonian Talmud

Humanity will pass. Thus men, peoples, races are
extinguished in their time. The gods, the great
gods ... must die one day; and on the ruins of
this world will flourish once more new races,
new empires and new gods.

 — Jules Michelet

The ideas that ruins awaken in me are grand. Everything is annihilated, everything perishes, everything passes, there is only the world that remains, only time which endures. How old it is this world! I walk between two eternities. Everywhere I cast my eyes, the objects which surround me announce an end and make me yield to that end which awaits me. What is my ephemeral existence in comparison with that of the rock which is effaced, this valley which is forged, with this forest which trembles, with these masses suspended above my head which rumbles. I see the marble tombs crumble into dust; and I do not want to die!

—Denis Diderot

I want to build

and raise new
the temples of Theseus and the stadiums
and where Perikles lived

But there's no money, too much spent
today. I had a guest
over and we sat together.

— Friedrich Hölderlin

There it lies, yard upon yard, only fragments,
one beside the other ... often only a piece of arm,
a piece of leg, as they happen to go along beside
each other, and the piece of body that belongs
right near them. Once the torso of a figure with
the head of another pressed against it, with the
arm of a third ... as if an unspeakable storm,
an unparalleled destruction had passed over this
work. And yet, the more closely one looks, the
more deeply one feels that all this would be less
of a whole if the individual bodies were whole.
Each of these bits is of such an eminent, striking
unity, so possible by itself, so not at all needing
completion, that one forgets that they are only
parts, and often parts of different bodies that
cling to each other so passionately there. One
feels suddenly that it is rather the business of the
scholar to conceive of the body as a whole and
much more that of the artist to create from the
parts new relationships, new unities, greater, more
logical ... more eternal.

— Rainer Maria Rilke

Yesterday.... I saw some ruins, beloved ruins
of my youth which I knew already... I thought
again about them, and about the dead whom
I had never known and on whom my feet
trampled. I love above all the sight of vegetation
resting upon old ruins; this embrace of nature,
coming swiftly to bury the work of man the
moment his hand is no longer there to defend
it, fills me with deep and ample joy.

— Gustave Flaubert

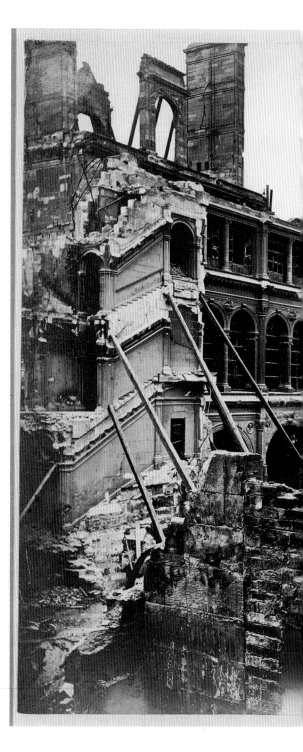

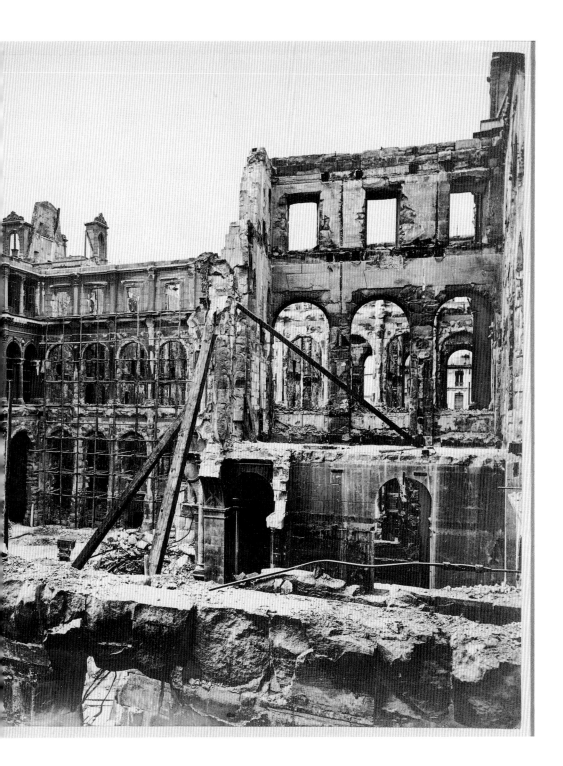

I would like to be at the gates of Paris with 500,000 barbarians and burn the whole city, what flames! What ruin of ruins! ... I have no love for the proletariat and I do not sympathize with its poverty but I understand and I share with it its hatred of the rich.

— Gustave Flaubert

Everything about history that, from the very beginning has been untimely, sorrowful, unsuccessful, is expressed in a face — or rather a death's head. And although such a thing lacks all "symbolic" freedom of expression, all classical proportion, all humanity — nevertheless, not only human existence as such but also the biographical historicity of an individual is pronounced momentously as a conundrum in this, its most decayed natural form.

— Walter Benjamin

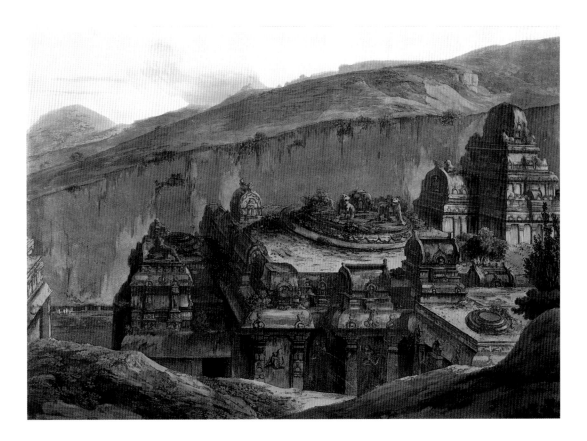

We have, in traversing the past — however extensive its periods — only to do with what is present.... The life of the ever present Spirit is a circle of progressive embodiments, which looked at in one aspect still exist beside each other, and only from another point of view appear as past. The grades which Spirit seems to have left behind it, it still possesses in the depths of its present.

— G. W. F. Hegel

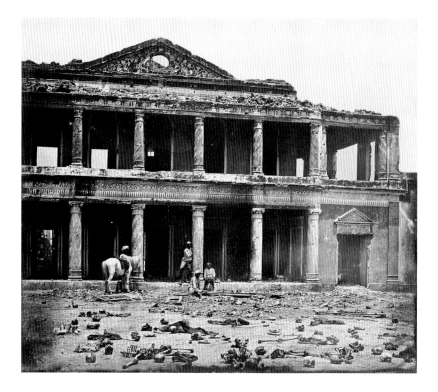

Nowhere, nowhere is there any trace of blood.
Neither on the hands of the assassin,
 nor under his fingernails,
not a spot on his sleeve, no stain on the walls.
No red on the tip of his dagger,
no dye on the point of his bayonet.
There is no sign of blood anywhere.
This invisible blood was not given in the service of kings
for a reward of bounty, nor as a religious sacrifice
 to obtain absolution.
It was not spilled on any battlefield for the sake of honor,
celebrated later in script on some banner.
The orphaned blood of murdered parents screamed out
 for justice;
no one had time or patience to listen to its cries.
There was no plaintiff, no witness;
 therefore no indictment.
It was the blood of those whose homes are made of dust,
blood that in the end became nourishment for dust.
 — Faiz Ahmad Faiz

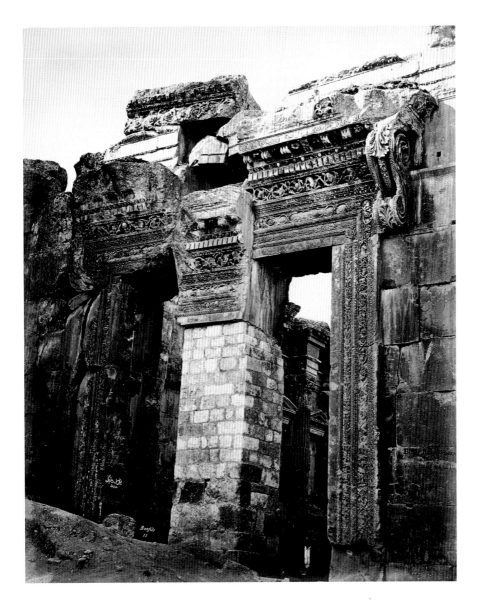

Always, when these resurrections took place, the distant scene engendered around the common sensation had for a moment grappled, like a wrestler, with the present scene. Always the present scene had come off victorious, and always the vanquished one had appeared to me the more beautiful of the two, so beautiful that I had remained in a state of ecstasy on the uneven paving stones or before the cup of tea, endeavoring to prolong or reproduce the momentary appearances of the Combray or the Balbec or the Venice which invaded only to be driven back, which rose up only at once to abandon me in the midst of the new scene which some-how, nevertheless, the past had been able to permeate.

— Marcel Proust

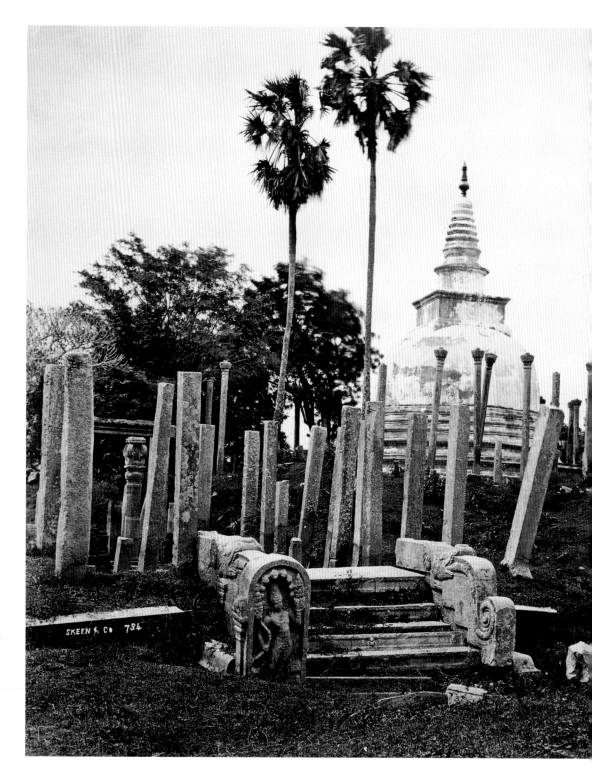

SKEEN & CO 734

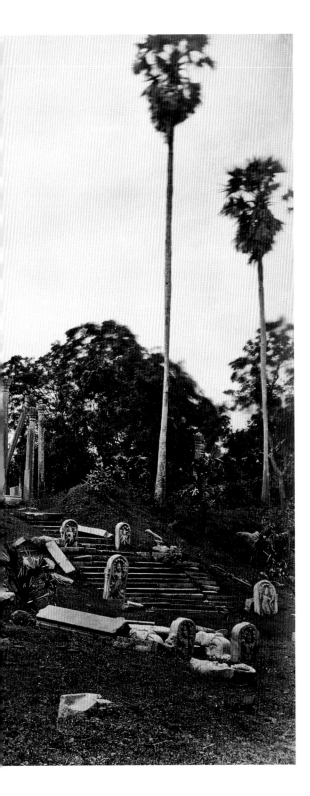

"Decay is inherent in all conditioned things.
Strive diligently!"
— Mahā Parinibbāna Sutta

Venerate that relic of him who is to be
venerated;
By doing so you will go from here to heaven.
— Milindapanha

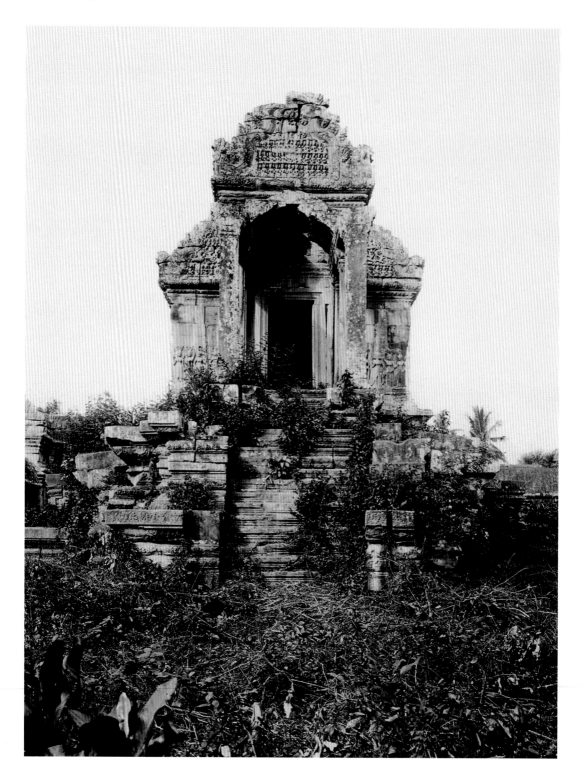

No foreign sky protected me,
no stranger's wing shielded my face.
I stand as witness to the common lot,
survivor of that time, that place.
— Anna Akhmatova

Earlier societies managed so that memory, the
substitute for life, was eternal and that at least
the thing which spoke Death should itself be
immortal: this was the Monument. But by mak-
ing the (moral) Photograph into the general and
somehow natural witness of "what has been,"
modern society has renounced the Monument.
— Roland Barthes

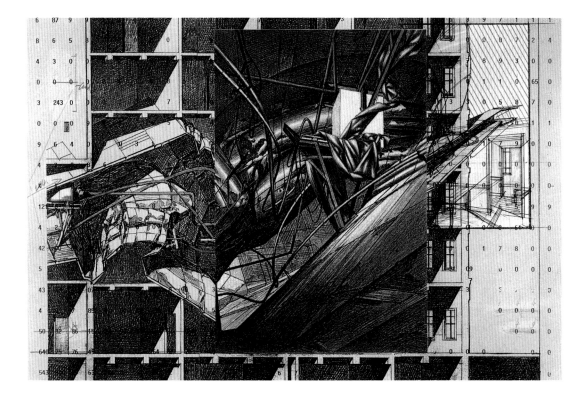

Wherever buildings are broken by the explosion
of bombs or artillery shells, by fire or structural
collapse, their form must be respected as an
integrity, embodying a history that must not be
denied. In their damaged states they suggest new
forms of thought and comprehension, and sug-
gest new conceptions of space that confirm
the potential of the human to integrate itself, to
be whole and free outside of any predetermined
totalizing system.... There is an ethical and
moral commitment in such an existence, and
therefore a basis for community.

— Lebbeus Woods

Many of the works of the Ancients have become
fragments, many of the Moderns are fragments
the moment they come into being.

— Friedrich Schlegel

Notes

These notes on the plates were compiled by Claire Lyons. Unless otherwise noted, translations are by Michael Roth.

p. 41 Sigmund Freud, *Three Essays on the Theory of Sexuality,* in idem, *The Standard Edition of the Complete Psychological Works of Sigmund Freud,* ed. and trans. James Strachey (London: Hogarth Press, 1953), 7: 222.

Marcel Proust, *Remembrance of Things Past,* vol. 3: *Time Regained,* trans. C. K. Scott Moncrieff and Terence Kilmartin (New York: Vintage, 1981), 903.

p. 42 Jacob Boehme, *De Incarnatione Verbi,* quoted in Carolyn Forché, *The Angel of History* (New York: Harper Collins, 1994), 72.

Etienne de la Rivière. French, active ca. 1545. Anatomical inset, corpse resting on ruins. Woodcut. Charles Estienne, *De dissectione partium corporis humani* (Paris: Apud Simonem Colinæum, 1545). 84-B31171.

This image of a corpse propped up by decaying masonry is one of sixty-four woodcuts in Charles Estienne's anatomy textbook *De dissectione partium corporis humani.* In this woodcut, probably adapted from one intended for the instruction of artists, the corpse assists in its dissection by holding open its chest. The medical inset, revealing the tonsils, septum, and palate, was added by Estienne's associate, the surgeon Etienne de la Rivière.

p. 43 Florent Schoonhoven, *Emblemata Florentii Schoonhovii, partim moralia, partim etiam civilia …* (Gouda: Apud A. Burier, 1618), 89.

Anonymous. German, 1480(?)–1544. Roman ruins at Mainz, Germany. Woodcut. Johann Huttich, *Collectanea antiquitatum in urbe atque agro Moguntino repertarum* (Mainz: Ioannis Schoeffer, 1525). 85-B26875.

Johann Huttich, a cleric and antiquarian, wrote several volumes on Roman history, including an illustrated treatise on the antiquities of his native Mainz. Mainz (ancient Moguntiacum) was the site of a Roman legionary camp in the late first century B.C.E. and a base for military campaigns against Germanic tribes along the Rhine frontier. In this engraving, a funerary monument dedicated to Drusus looms over the houses and churches of current-day Mainz. The Roman funerary inscription on the left, referring to a local member of the legionary force, offers more explicit epigraphic testimony of the city's historical past.

p. 44 Georg Simmel, "The Ruin," in Kurt H. Wolff, ed., *Essays on Sociology, Philosophy, and Aesthetics* (New York: Harper, 1965), 261–62.

Giovanni Battista Piranesi. Italian, 1720–1778. Ruins of an ancient tomb and aqueduct, circa 1740s. Etching. 900153B*.

This etching of a Roman funerary monument and aqueduct, probably produced in the 1740s, is among the earliest works published by the Italian architect and draftsman Giovanni Battista Piranesi. Small human figures admire the monumental fragments of Roman architecture, still magnificent in their decay. Juxtaposing actual and imaginary elements of classical antiquity, Piranesi championed the achievements of Roman architects and engineers and the grandeur of their buildings.

p. 45 Voltaire, *The Lisbon Earthquake,* in idem, *The Portable Voltaire,* ed. Ben Ray Redman (New York: Viking, 1968), 560-63.

Martin Engelbrecht. German, 1684–1756. *Præsentation eines Erdbebens.* Set of seven

etchings, hand colored; modern stand (Augsburg: Martin Engelbrecht, late 1750s). 96.R.39.

Martin Engelbrecht's optical theater, *Præsentation eines Erdbebens,* presents a brilliantly colored, three-dimensional scene of chaos and devastation. Accompanied here by a modern wooden stand slotted to hold the cards, the theater consists of seven etchings that form a perspective view of the destruction of a city by earthquake. Presumably that city is Lisbon, which was hit by a major earthquake in 1755.

pp. 46–47 Jean-Jacques Rousseau, *Emile: Or, On Education,* trans. and ed. Allan Bloom (New York: Basic Books, 1979), 343. Rousseau is quoting Herodotus.

Joseph Michael Gandy. English, 1771–1843. *The Persian Porch and the Place of Consultation of the Lacedemonians,* circa 1816. Watercolor and gouache over pen and pencil, on paper. 910072*.

The Persian Porch represents architect Joseph Michael Gandy's visionary reconstruction of ancient Sparta. Based on the second-century C.E. description of the city and its monuments by Pausanias (*Description of Greece,* III.11), Gandy's scene includes an extravagant array of temples, statuary, and sacrificial altars. The actual remains of Sparta visible at this time were few, since spolia from the ancient city had been used to build the nearby Byzantine town of Mistra. Exhibited at the Royal Academy in 1816, this unpublished architectural fantasy is a primary document in English Neoclassicism.

p. 48 John Ruskin, *The Seven Lamps of Architecture,* in idem, *The Genius of John Ruskin,* ed. John D. Rosenberg (Boston: Routledge & Kegan Paul, 1963), 132.

Frederick MacKenzie. British, 1788(?)–1854. Theater at Patara, Turkey, circa 1840. Drawing, ink and wash, after a sketch by William Gell. 840199*.

Drawings of the Graeco-Roman theater at Patara in Lycia were commissioned by the Society of Dilettanti in London for publication in *Antiquities of Ionia,* folio volumes recording the results of expeditions to little-known archaeological sites on the Turkish coast. The Dilettanti, an aristocratic association of connoisseurs, sponsored archaeological travel in Italy, Greece, and Asia Minor and underwrote the publication of deluxe volumes to encourage the appreciation of classical antiquity.

pp. 50–51 Lord Byron, *Childe Harold's Pilgrimage* (London: John Murry, 1869), 244, canto 4.

Francis Frith. English, 1822–1898. Fountains Abbey, England, circa 1859. Albumen print. 96.R.32.

Francis Frith took this photograph of Fountains Abbey, the largest monastic ruin in England; the print was made in the late 1860s at Frith's Reigate establishment, one of the largest publishing firms of the day. On the left are the remains of a guest house built in the 1160s for high ranking visitors, and in the background is Huby's Tower, built in the late fifteenth century by Abbot Huby as a monument to the abbey's importance.

p. 52 William Wordsworth, "Lines, Composed a Few Miles above Tintern Abbey, on Re-visiting the Bands of the Wye during a Tour," in idem, *Selected Poetry,* ed. Mark Van Doren (New York: Random House, 1950), 104.

Roger Fenton. British, 1819–1869. Tintern Abbey, England, circa late 1850s–1862. Albumen print. 96.R.34.

This view of the Cistercian Abbey at Tintern near the Welsh border was taken by

Roger Fenton, one of the foremost photographers of English landscapes. The melancholy beauty of the fragmentary architecture and idyllic setting appealed to the Romantic sensibilities of Victorian audiences. Founded in the twelfth century, Tintern was dissolved and despoiled in the sixteenth century, when its roofs were stripped for their lead. Centuries of neglect left little standing but the walls.

pp. 54–57 Johann Wolfgang von Goethe, "Den Vereinigten Staaten," in idem, *Goethes Werke: I. Abtheilung, 5 Band* (Tokyo: Sansyusya, 1975), 137.

Lucretius, *The Way Things Are,* trans. Rolfe Humphries (Bloomington: Indiana University Press, 1969), bk. 6, lines 594–608.

Disaster postcards from the American photographic postcard collection, 1900s–1930s. 89.R.46.

These four postcards document the destruction caused by earthquakes in California. The photograph of Kearney Street, San Francisco, was taken just after the 1906 earthquake and fire; that of Huntington Park High School was taken after the 1933 Long Beach earthquake.

p. 58 From the Talmud, quoted in Yosef Hayim Yerushalmi, *Zakhor: Jewish History and Jewish Memory* (New York: Schocken Books, 1989), 23.

Jules Michelet, *Histoire romaine* (Paris: Hachette, 1831), 47.

Nicolas Béatrizet. French, active 1540–1565. The Colonna Sancta at St. Peter's Basilica, Rome. Engraving. *Speculum romanae magnificentiae* (Rome: Antoine Lafréry et al., 1544[?]–1602). 91-F104.

The so-called Colonna Sancta was long believed to come from the ruins of the Temple of Solomon in Jerusalem. The tradition that identified it as the column on which Jesus leaned gave scriptural significance to an architectural fragment. Since at least the fifth century C.E., the column has stood in St. Peter's Basilica in Rome, and it was among the highlights for visiting pilgrims and artists in the eternal city. A spiral shaft wreathed with tendrils, the column is most likely the product of a Greek workshop of about 200 C.E.

p. 59 Denis Diderot, *Salons,* ed. Jean Seznec and Jean Adhemar (Oxford: Clarendon Press, 1963), 3: 228–29.

Charles-Louis Clérisseau. French, 1721–1820. Interior of the Temple of Diana at Nîmes, France. Engraving. *Antiquités de la France* (Paris: P. Didot l'aîné, 1804). 88-B2179.

In the mid-eighteenth century a water shortage in the French city of Nîmes resulted in the reconstruction of ancient aqueducts belonging to a Nymphaeum, or fountain complex, dating from the Roman Imperial period. The area was transformed into a public garden by excavating, removing, and reutilizing the Roman ruins. This study of the so-called Temple of Diana was made by the artist, architect, and archaeologist Charles-Louis Clérisseau, who visited the complex in about 1767, as the transformation was underway.

p. 60 Friedrich Hölderlin, *Hymns and Fragments,* trans. Richard Sieburth (Princeton: Princeton University Press, 1984), 245.

Anonymous, *Hellenicorama or Grecian Views.* Cards used for practice of watercolor technique. Aquatint prints, hand colored (London: J. Burgis, circa 1800–1825). 94.R.57.

Hellenicorama or Grecian Views is a boxed set of twenty-four cards depicting landscape views of Greece and the ruins of well-known ancient monuments. Young art students could rearrange the cards to create imaginary landscapes in order to practice watercolor technique. The cards reflect a long-standing pictorial tradition in which classical ruins form the backdrop for Arcadian scenes of dancing maidens, shepherds, and the episodes of rural life.

pp. 60–61 Rainer Maria Rilke, *Letters of Rainer Maria Rilke, 1892–1910,* trans. Jane Bannard Greene and M.D. Herter Norton (New York: Norton, 1945), 79–80.

Giovanni Montiroli. Italian, 1807–1879. Finds from excavations in the area of the Tomb of the Baker, Rome. Watercolor. Giuseppe De Fabris, *Porta Gregoriana al Monumento dell'Acqua Claudia...* (Rome: n.p., 1840). 900013*.

Giuseppe De Fabris commissioned the architect Giovanni Montiroli to prepare a series of original watercolors of the excavations in the area of the Porta Maggiore and Sepulcrum Eurysacis, the so-called Tomb of the Baker, in Rome. Bound in a fine gilt-stamped red morocco presentation volume, the drawings were given to Pope Gregory XVI, patron of the restoration project. The first-century B.C.E. Tomb of the Baker had been incorporated into the city gate during the early fifth century C.E. and was uncovered during investigations in 1838. Numerous fragments of sculpture and inscriptions, such as those shown in this plate, were subsequently reutilized as decorative elements in the surrounding walls.

pp. 62–63 Gustave Flaubert, *Correspondance: 1847* (Paris: Louis Conard, 1926), 271.

Gustave Flaubert, *Souvenirs, notes et pensées intimes,* ed. Lucie Chevalley Sabatier (Paris: Buchet et Chastel, 1965), 53.

Alphonse Liebert. French, 1826–(?). Interior court of burned Hôtel de Ville, Paris, 1871. Albumen print. 93.R.121*.

Embittered at France's defeat by the Prussians and the five-month siege of the city, the volunteer citizen army of Paris rose up against the central government in 1871, establishing the Paris Commune. As the central government reasserted control, the Communards destroyed public buildings like the Hôtel de Ville. Reconstruction of the Hôtel de Ville began within weeks of the Commune's defeat.

p. 64 Walter Benjamin, *The Origin of German Tragic Drama,* trans. John Osborne (London: Verso, 1985), 166. Translation modified by Steven Lindberg.

Anne and Patrick Poirier. French, 1941–, 1942–. *Memoria Mundi (No. II),* 1990–91. Wood, glass, paper, book, and plaster.

The Poiriers have produced a body of work that reunites the archive of a fictive archaeologist-architect who has devoted himself to the excavation of a site called "Mnemosyne" (the Greek word for memory). In the work *Mnémosyne,* these fragments are presented in a cabinet, reminiscent of the cabinets of curiosities once used to display objects of art and nature. On top of the cabinet and inside its drawers are a cast taken from a broken sculpture, a cranium containing an ancient ruined theater, a field notebook, and other artifacts that allude metaphorically to the archaeological project of piecing together the past.

p. 65 G. W. F. Hegel, *The Philosophy of History,* trans. J. Sibree (New York: Dover, 1956), 25.

Thomas Daniell. English, 1749–1840. Kailasa Temple at Ellora, India, 1790s. Aquatint

print after a drawing by James Wales. *Hindoo Excavations in the Mountain of Ellora; Near Aurungabad, in the Decan, in Twenty-Four Views* (London: T. Daniell, 1803). 89-B11520.

The artists Thomas and William Daniell are best known for their six-volume publication of aquatint prints titled *Oriental Scenery,* an elegantly illustrated account of the architecture, archaeology, and landscapes of the Indian subcontinent. In the early 1790s, the Daniells explored the cave temples of Ellora with James Wales, who drew the view of the Kailasa Temple (Cave 16), after which this plate was made. Dedicated to the Hindu god Shiva, the late eighth-century rock-cut temple and shrine buildings are decorated with carved reliefs of animals and narrative scenes.

p. 66 Faiz Ahmad Faiz, "No Sign of Blood," trans. Naomi Lazard, in Carolyn Forché, ed., *Against Forgetting: Twentieth-Century Poetry of Witness* (New York: Norton, 1993), 524–25.

Felice Beato. British, circa 1830–1903. Sikandrah Bagh after the Slaughter of the Rebels by the 93rd Highlanders of 4th Panjal N.I., 1858. Albumen print. *Lucknow.* J. Paul Getty Museum: 84.XO.1168.7.

In 1857 a number of Indian regiments turned against their British officers, triggering a widespread rebellion in northern India against British rule. The expatriate colony at Lucknow was besieged, and its British residents eventually abandoned the city. The British army returned to Lucknow in November 1857 and slaughtered the rebels. By the time Felice Beato arrived some four months later to photograph the damaged palace of Sikandrah Bagh, the remains of the deceased had been picked clean by vultures. Beato is reported to have disinterred and rearranged the bones so as to intensify the impact of the photograph.

p. 67 Marcel Proust, *Remembrance of Things Past,* vol. 3: *Time Regained,* trans. C. K. Scott Moncrieff and Terence Kilmartin (New York: Vintage, 1981), 908.

Félix Bonfils. French, 1829–1885. Gateway to the Temple of Bacchus, Baalbek, Lebanon, early 1870s. Albumen print. *Souvenirs d'Orient.* (Alais: Félix Bonfils, 1876). J. Paul Getty Museum: 84.XO.1167.38.

A day's journey from Beirut stand the monumental Roman ruins at Baalbek. This photograph by Félix Bonfils records one of the earliest interventions to preserve the ancient architecture of the site. The keystone of the gateway of the Temple of Bacchus had been slipping for centuries and would have soon fallen had the British consul not ordered the installation of a brick support in about 1870. The striking image of the falling keystone also appears in eighteenth-century illustrations of the site and connotes the inevitable dissolution of a once grand and powerful empire.

pp. 68–69 Mahā Parinibbāna Sutta (The Great Sutta of the Parinibbāna), in Trevor Ling, ed., *The Buddha's Philosophy of Man: Early Indian Buddhist Dialogues* (London: J. M. Dent & Sons, 1981), 204.

Milindapanha (Melinda's Questions), trans. B. Horner, in *Sacred Books of the Buddhists,* vol. 22 (London: Luzac, 1963), 250.

W. H. L. Skeen & Co. British, active 1870s–1890s. Thūpārāma Dāgäba, Sri Lanka, late nineteenth century. Albumen print. 96.R.52.

This photograph of Thūpārāma Dāgäba, Anuradhapura, was taken in the late nine-

teenth century by the British photographic firm W. H. L. Skeen & Co., which was based in Colombo. Thūpārāma, built in the third century B.C.E. to house the collarbone of the Buddha, is the oldest shrine in Sri Lanka. The carved pillars in front are the remains of the vatadāgā (circular colonnaded temple) built in the second century C.E. to protect the shrine, its images, flower altars, and worshippers. The roof of the vatadāgā, a wood construction once decorated with garlands of gold, had long since decayed and disappeared when the photograph was made, leaving only the stone pillars.

pp. 70–71 Roland Barthes, *Camera Lucida: Reflections on Photography,* trans. Richard Howard (New York: Noonday Press, 1981), 93.

Urbain Basset. French, 1842–1924. Exterior view of a building at Angkor, Cambodia, about 1896. Albumen print. 96.R.127.

A series of albumen photographs dating to the 1890s records the splendid temples and monuments at the Khmer capital at Angkor, which flourished between the ninth and fourteenth centuries C.E. The sculptor and amateur photographer Urbain Basset accompanied a French expedition sent to document the architecture and make casts of the elaborate relief sculptures. Basset's photographs are important witnesses to the state of the monuments before extensive excavation and restoration projects were undertaken after the turn of the century, and before the destruction and looting that have occurred during subsequent periods of political turbulence.

p. 71 Anna Akhmatova, "Requiem," trans. Stanley Kunitz and Max Haywood, in Carolyn Forché, ed., *Against Forgetting: Twentieth-Century Poetry of Witness* (New York: Norton, 1993), 101.

Désiré Charnay. French, 1828–1915. Monumental head at Izamal, Mexico, circa 1859. Albumen print. 95.R.126*.

This monumental stucco mask no longer exists. Désiré Charnay found the effigy in 1859, while photographing and making casts of Mesoamerican ruins for the French government. It was once located at the foot of the Second Pyramid of Izamal, a classic and postclassic Maya site partially destroyed by the Spanish in the sixteenth century. Charnay's unusual photographs illustrated published studies of ancient ruins in the Americas and are still considered useful documents.

p. 72 Lebbeus Woods, *War and Architecture,* trans. Aleksandra Wagner (Princeton: Princeton Architectural Press, 1993), 14.

Friedrich Schlegel, *Schriften zur Literatur,* ed. W. Rasch (Munich: DTV, 1972), 32.

Lebbeus Woods. American, 1940–. Building facade: *Berlin Free Zone* project, 1990. Mixed media, mainly electrostatic printing, colored pencil, pastel, and ink on paper. 950081**.

The *Berlin Free Zone* project was executed by the American-born architect Lebbeus Woods in 1990, after the fall of the Berlin Wall. In this series of drawings, Woods proposes the creation of a "freezone" providing the citizens of a reunited Berlin with a space for a radical transformation of their living conditions. An empty shell that is deserted because of its proximity to the Wall, the building appears as a ruin, torn to expose the underlying organic structures. Woods's design allows for movement and nonhierarchical interaction in otherwise authoritarian constructions.

Archives in Ruins:
The Collections of the Getty
Research Institute

Claire Lyons

R uins, it has been observed, are essentially features of modernity. In antiquity, ruins did not have the aesthetic significance that they have had since the Renaissance. The Cyclopean fortifications of Bronze Age citadels recalled for later generations the deeds of hero-ancestors who were closer to deities than to humans. More often, the debris of the past formed the foundation for subsequent building or, if too sacred to discard, was reburied. It was in the imagination of the Renaissance spectator who regarded collapsed remains at some remove of space and time that the irresistible decay of a ruin first became differentiated from dilapidation. Constituted by memory and distance, ruins are proxies for a past that is continually reinvented by the present.

The ruin and the archive take their original meaning from the terms for an edifice — the one collapsed, disordered by time and history (*ruina* in Latin), and the other intact, an ordered repository of historical documents (from the Greek *archeion*). Just as the archive preserves the past through the graphic witness of original records, the ruin, too, constitutes a form of writing in which historical consciousness is expressed through the material witness of fragments. The pleasure and immediacy intrinsic to the paper residue of past lives is not unlike the pleasure of association experienced by following the footsteps of predecessors through the overgrown remains of antiquity. Subject to chance and selection and therefore inevitably incomplete, ruins and archives nevertheless grant an intimate dialogue with history's protagonists.

The illustrated rare books, artists' sketches, and vintage photography on display for "Irresistible Decay" represent a larger body of primary sources held in the archives of the Getty Research Institute.[1] The greatest concentration of material consists of photographs numbering in the tens of thousands, which document Classical and Medieval antiquities in Europe and the Mediterranean. Sites in North Africa, the Ottoman Empire, Southeast Asia, and Latin America are recorded as well. These images, taken over the past 150 years, portray monuments that have been the objects of study and contemplation for centuries. Archaeological views and cityscapes show the changes wrought by time, including the physical marks of natural deterioration, disaster, war, urban development, tourism, and looting. Illustrated books of the sixteenth to the nineteenth century are a second considerable source of imagery. They depict not only the state of extant remains in the age before the

photographic lens, but, more important, the ways in which they were assimilated into visual vocabularies. The holdings of architectural treatises and guides to major European cities (particularly Rome), antiquarian catalogs, and travel descriptions are strong points of the collections. Original sketchbooks and designs created by artists and architects on the Grand Tour register exercises in draughtsmanship and sources of inspiration. Correspondence exchanged between scholars, collectors, and arts administrators illuminates ongoing debates over interpretation, ownership, and preservation. Together, these representations of ruins illustrate how a consciousness of the past emerges from subjective responses to its remains. What characterizes a ruin, as opposed to an abandoned or damaged structure? By what criteria are ruins preserved, reconstructed, or demolished? How do ruins authenticate mythological origins, exemplify the achievements of past cultures, transmit moral precepts, and sustain and promote national identities?

It is instructive to consider how and why artists depicted ruins in illustrations from the Renaissance to the modern period. The evolution of ruins from disintegrating structures to historical monuments of cultural, political, and historical significance occurred as the understanding of their form and meaning advanced.[2] Abandoned buildings were initially seen as little more than material remnants connected with legends and myths of origin, and they served to legitimize the authority of sacred and secular traditions. As Northern European scholars applied more sophisticated technical and interpretive methodologies to the remains of ancient architecture, the ruins of classical antiquity came to be regarded as paradigms of artistic excellence through which humanistic values were transmitted. Travel and archaeological exploration brought to light a quantity of new material in original, often non-European contexts. These changes can be traced through artists' representations of ruins, from early woodcut emblems to technically proficient architectural drawings, elaborate allegorical frontispieces, utopian landscapes, and documentary photographs.

In the absence of written accounts, antiquarians looked to the material traces of the past for tangible evidence of human history. The desire to establish direct continuities between past and present encouraged the publication of regional guides and catalogs of antiquities that, although colored by civic rivalry, illustrate the evolution of historical explanation. Among the Research Institute's collections are a number of early illustrations that situate ancient architecture somewhere between legend and utility. Johann Huttich's 1525 treatise on Roman Mainz, for example, pairs the crumbling brickwork of military fortifications with an inscribed funerary stele (p. 43), equating epigraphical sources with anonymous remains in order to underscore the ancient origins of the city.[3] One of the first studies of historical topography, a map of Nola in South Italy published by Ambrogio Leone in 1514, uses miniature icons to mark the location of Greek and Roman cemeteries, baths, temples, and amphitheaters within the city walls (fig. 1). Still in use three centuries later, Leone's map preserved ancient features that had all but disappeared by

Fig. 1. Girolamo Mocetto, map of ancient monuments at Nola (South Italy), woodcut from Ambrogio Leone, *De Nola...*, 1514. Los Angeles, The Getty Research Institute for the History of Art and the Humanities, acc. 90-B32941.

Fig. 2. Megalith at Albersdorf, Germany, engraving from Johann Georg Keyssler, *Antiquitates selectae septentrionalis et celticae...*, 1720. Los Angeles, The Getty Research Institute for the History of Art and the Humanities, acc. 94-B18715

the nineteenth century. A similar map in Marco Fabio Calvi's *Antiquae urbis romae* (1532) placed monuments extant in the time of Pliny within the circumference of the walls of Rome. This map and the other woodcuts in this volume head a long series of cartographic investigations that sought to frame ancient monuments within a continuous historical tradition and so to rescue them from oblivion.[4]

Remote prehistory was also subject to the patriotic intentions of local historiographers. Antiquarians were intrigued by primitive structures in northern Europe that had been formed from massive standing boulders. Engravings published in 1720 by the German traveler J. G. Keyssler depict the "pagan altar" at Albersdorf in Germany in a sacred grove (fig. 2), excavators exploring the "giants' bed" at Drenthe in Holland, and the stone circles in England. Keyssler's illustrations present prehistoric ruins simultaneously as valid subjects of scientific inquiry and as legendary apparitions of pagan cults.[5] Such divergent approaches produced numerous competing theories on the origin of megaliths. Inigo Jones imposed a regular geometry on his plan of Stonehenge, published posthumously in 1655, in order to assert that its "Tuscan" style represented an early phase of Britannic classicism that developed after the Roman occupation.[6] In the 1740s, William Stukeley revived a long-standing theory by identifying megalithic monuments as Druid temples where a primitive form of patriarchal Christian worship was practiced. From the eighteenth century to the present day, many observers have attributed astronomical significance to the alignment of the stone circles, linking science and myth in the concept of a solar temple.

Abandoned buildings were also reclaimed for purely utilitarian purposes that acquired added significance from the former mythological or sacred status of the site. Drawing on the prestige of antiquity, architectural and sculptural fragments (spolia) were incorporated into new structures in a process that eroded surviving monuments while embellishing their modern replacements. The practice of reutilization was ubiquitous in urban centers throughout the former Roman provinces. The Baths of Caracalla are identified in the caption below Marco Sadeler's engraving in *Vestigi delle antichità di Roma* (1660) as a major source of ready-made materials for papal and aristocratic building programs.[7] Borrowed architectural friezes, portrait heads, and inscriptions functioned as visual quotations and occasionally can be read as narrative statements. In the walls of the fifteenth-century Orsini castle in Castel Madama (Lazio), Roman funerary inscriptions and later reliefs form a mosaic that alludes to the aristocratic ancestry and intellectual cultivation of its owner (fig. 3).[8] These messages also stand behind the reuse of local antiquities in the facade and courtyard of the fifteenth-century Palazzo Carafa Maddaloni in Naples, pictured in a 1688 guide published by Pompeo Sarnelli.[9] More than a decorative program, however, Diomede Carafa's use of classical antiquity was intended to place the classical heritage of southern Italy on a par with that of Rome and Tuscany. The recycling of antiquity thus performed a specific political function.

Fig. 3. Max Hutzel, spolia in Orsini Castle, Castel Madama,
Italy (detail), ca. 1960–1985, silver gelatin print. Los
Angeles, The Getty Research Institute for the History of
Art and the Humanities, acc. 94-F92.

The extant remains of Greek and Roman temples were frequently incorporated into churches. The first-century C.E. Temple of the Dioscuri provided a suitably impressive superstructure for the church of San Paolo Maggiore in Naples, as did numerous other ancient temples in Rome and elsewhere. Like the Parthenon in Athens, the Temple of Bacchus in Baalbek (pp. 19, 67) was sanctified as a site of worship over centuries of successive occupations.[10] Columns that once supported the pediments of the sixth-century B.C.E. Temple of Athena are still visible in the walls of the Duomo in Syracuse, shown in a 1613 engraving published by the Sicilian scholar Vincenzo Mirabella e Alagona.[11] Conqueror of a pagan empire and rightful heir to its achievements, the Catholic Church appropriated Rome's material legacy to affirm its role as spiritual capital and seat of temporal power. The political and cultural aspirations that ruins and antique sculptures satisfied did not, however, altogether outweigh their aura as relics. The display in the Vatican Treasury of the "Colonna Sancta" (p. 58), a spiral column believed to be the one on which Jesus leaned in the Temple of Solomon, transformed what was actually a fourth-century C.E. spolium into an instrument of scriptural authority. That it was a highlight on the itinerary of sixteenth-century visitors is clear from its inclusion in the *Speculum romanae magnificentiae* (1544[?]–1602), a series of engravings sold individually to tourists by the publisher Antoine Lafréry. It was at this time that ambitious excavation and restoration projects were initiated by the Church, which erected stylite statues of St. Peter and St. Paul atop the columns of Trajan and Marcus Aurelius. Monumentalized in the late eighteenth-century etchings of Giovanni Battista Piranesi, the two apostles dwarf the triumphs of Roman emperors over barbarians that are recounted in the friezes below.[12]

The Research Institute's most significant sources for the iconography of ruins consist of images informed by the documentary interests of architects, artists, and antiquarians in the sixteenth through nineteenth centuries. Woodcuts illustrate the splendors of *sancta antiquitate* that inhabit Poliphilos's reveries of love in the *Hypnerotomachia di Poliphilo* (1499), a contemplation on what ruined monuments must once have been. These emblems stand at the juncture of fiction and fact. The motto *Roma quanta fuit ipsa ruina docet* (how great was Rome, the ruins themselves show) inscribed on the frontispiece of Sebastiano Serlio's *Tutte l'opere d'architettura* (1540) translated the dream of the eternal city into a pragmatic paradigm and held up its remains, magnificent even in their decadence, as worthy of emulation. Volume three of this treatise was the first such publication to rely chiefly on the visual imagery of ruins. Together with the seminal manual *I quattro libri dell'architettura* of Andrea Palladio, it articulated a canon of ancient Roman "models" and disseminated Renaissance architectural theory throughout Europe. Publications that focused on individual building complexes, such as Francesco Bianchini's studies of the Palatine (1738) and tombs on the via Appia (1727) or Gian Domenico Bertoli's multivolume publication on the site of Aquileia (1739), reveal the close attention that was devoted to architectonic

details in original contexts as a result of archaeological excavation and first-hand observation.[13]

As artists undertook more accurate representations of ancient fragments, their drawings were collected in illustrated volumes or compendia known as "paper museums." The resulting corpus of specimens was used to categorize and reconstruct unwritten history. The frontispiece to the Comte de Caylus's seven-volume *Recueil d'antiquités* (1752–1767) illustrates a process of prizing the evidence from a tumbled pile of masonry in order to reassemble the grandeur of antiquity, embodied in the form of a classical temple (p. 10). The aim of collections of archaeological artifacts such as those published by Caylus and Bernard de Montfaucon was not so different from that implicit in many studies of imperial Roman architecture. These authors strove to reconstruct the whole from the sequence of its parts—"history proved by monuments."[14] The ordering of fragments to articulate layers of knowledge suggests interesting points of contact with the visual iconography of natural history, where half-buried ruins, artifacts, and fossils play parallel roles in thought about change, time, and destiny.

Contemporary artistic conventions of setting and style played a normative role that shaped the interpretation of ruins and their place in history. Despite the seeming photographic accuracy with which ancient monuments were portrayed by such brilliant draughtsman as Piranesi and Pietro Santi Bartoli, a closer look at this pictorial tradition shows that fidelity to the originals was not always the primary concern.[15] The inclination to restore buildings according to precepts compiled by the Roman author Vitruvius and the desire to glorify the artistic heritage of Rome resulted in idealized representations that merge the particularities of different periods and styles. The etchings of Piranesi reflect current debates on the comparative worth of Roman and Greek architecture. Ancient mossy masonry, shadowed by cypress or a lone palm in a tangle of undergrowth, is magnified to imposing stature in proportion to the small figures who gaze in rapt admiration at its smallest details (pp. 4, 44).[16] The transitory nature of human achievement and pleasure, the recognition of impending death *(memento mori)*, and the reassurance of salvation are also evident in the illustrations of ruins. Echoed in landscape painting and poetry of the Romantic period, the iconography of classical ruins inevitably influenced the portrayal of people and places in very different parts of the world.

The academic training of several generations of artists, coupled with the increased production and dissemination of illustrated books, was responsible for the diffusion of classical style in architecture, painting, sculpture, and the decorative arts. The frontispiece of a publication of drawings of English Neoclassical residences by Robert and James Adam (1778–1779) is emblematic: against the backdrop of a Corinthian colonnade, a student is guided by the personification of Design to Minerva, who points to a map of Italy and Greece.[17] This becomes a stock theme in archaeological illustration, as, for example, in an illustration from the multivolume survey by Charles-Louis

Fig. 4. Marie-Joseph Peyre, architectural fragments in classical landscape, ca. 1753–1785, ink and wash drawing. Los Angeles, The Getty Research Institute for the History of Art and the Humanities, acc. 840015*.

Fig. 5. Jacques-Louis David, Roman Forum, ca. 1775–1784, ink and wash drawing. Los Angeles, The Getty Research Institute for the History of Art and the Humanities, acc. 940049*.

Clérisseau, *Antiquités de la France,* first published in 1778, in which an artist draws among the collapsed yet still monumental ruins of the Temple of Diana in Nîmes (p. 12).[18] Reflections of the "school of antiquity" pervaded virtually all aspects of architectural design from major civic and religious commissions to proposals for cemeteries and funeral monuments, theater and stage scenery, and landscape gardening. These categories offer resonant metaphors that can be explored in graphic production from the Medieval period to the present: ruins and resurrection (p. 53), the staged aspect of ruins as performance (p. 66), and the "naturalization" of the ruin in *antikengarten* and in artificial landscapes (fig. 4 and p. 6).

Documentary and reconstruction drawings in the Research Institute's holdings furnish valuable information on the state of the recovered remains, artistic process, and the creative spirit of the age. The collection ranges from an early plan and elevation of the Tomb of the Servili, dating to about 1500, to a significant number of eighteenth- through nineteenth-century drawings by Prix de Rome recipients who studied at the Académie Française in Rome. In the work of artists and architects who approached antiquity as a source for figural motifs, archaeological remains were transformed from inspirational paradigm to official curriculum. The volume of ninety-two leaves of drawings by Marie-Joseph Peyre (circa 1753–1785), a leading exponent of Neoclassicism in France, presents architectural fragments in Italianate landscapes (fig. 4).[19] A smaller sketchbook attributed to Charles Percier (circa 1790) contains exquisitely detailed renderings of both ancient Roman structures and modern villas.[20] The strict syllabus of the Académie, which limited the options for student exercises to a set number of approved monuments, was expanded in the early decades of the nineteenth century. Later drawings by Jean-Nicholas Huyot, Simon-Claude Constant-Dufeux, Matthieu-Prosper Morey, and others record observations made outside Rome, from Praeneste to the rock-cut tombs of Etruria and the "rediscovered" Greek temples of South Italy and Sicily.[21] The domestic quarter of Pompeii and its superb polychrome wall paintings were a magnet for all who followed the progress of the disinterment of the buried city. Brightly hued frescoes and architectural revetments triggered heated debates about the use of color on ancient buildings, a radical proposal for monuments that had always been perceived in the pristine tones of natural stone.

Few artists incorporated classical themes and idioms to the extent that Jacques-Louis David did following his sojourns in Rome between 1775 and 1784. A critical record of his work is preserved in an album composed of ninety-nine drawings assembled by the artist as an *aide-mémoire* and personal account of his artistic development.[22] One of eleven or more original volumes of which several remain intact, David's dense collage of images illustrates the depth of his engagement with the visual material at hand and its perceived moral content (fig. 5). During the French Revolution, the science of antiquity was viewed not as a nostalgic return to an idyllic past but as an explicit program of action for the immediate future. Equated with political

liberty and freely adopted in pageants and festivals of the Republic, the iconography of the antique suffused fashion, coiffeur, drama, literature, and cuisine. For Hubert Robert, David's predecessor at the Académie, the imaginative role of ruins is expressed in several preliminary sketches for finished compositions, including *Le dessinateur d'Antiques* (1796) and his proposals for the reinstallation of the Louvre galleries. One of Robert's designs fancifully (but less practically) figures the Louvre as a crumbling ruin. In a reversal of the usual framing of the ruin as an otherworldly "not here, long ago" subject of the European gaze, fantasy views of Continental cities as open-air archaeological sites became a recurrent motif in literature and art. Joseph Michael Gandy's watercolor *Ruins of the Bank of England,* and *Le Néo-Zélandais,* Gustave Doré's engraving that pictures a native of New Zealand observing the ruins of London, are two among many reflexive meditations on the precariousness of posterity.[23]

Fantasy and contemporary politics also played a large part in the interpretation of monuments encountered by travelers in the Mediterranean and beyond. Joseph Michael Gandy's visionary reconstruction of ancient Sparta (circa 1816; pp. 46–47) elaborated on Pausanias's brief description of the city and the few stones that were still preserved. In this unpublished watercolor, Gandy imagines a theatrical scene of imposing temples, porticoes, and sacrificial altars. The juxtaposition of the monumental cityscape and primitive natural forms of the Taygetos mountains presents a transcendent view of past grandeur that also infuses the work of Piranesi. A number of Gandy's unpublished stage sets and book illustrations adopted the classical agora, sanctuary, or isolated megalith as backdrops. These themes have a long history in theater design, including painted scenery in folly gardens and ephemeral festival buildings.[24]

Although Gandy never visited the Greek mainland, architects in his circle traveled under the auspices of the Society of Dilettanti, a London-based private association of aristocratic connoisseurs that outfitted expeditions to Greece and Asia Minor. The broken outlines of the theater at Patara (Lycia) and shadowy undergrowth (pp. 48–49), drawn by William MacKenzie shortly after the 1811 mission, evoke a melancholy mood. The inscription on an altar in the foreground, *mousoi kai mnemosynes,* reminds the viewer that memory was the mother of the muses in classical mythology. Romantic site views commissioned by the Dilettanti were later engraved in publications for its affluent readership. Letters by archaeologist-travelers William Gell (circa 1812) and John Turtle Wood (circa 1863–1890) describe the vicissitudes of excavation during the nineteenth century in the eastern Mediterranean, where archaeologists parried with local officials and brigands for the spoils of ancient monuments.[25]

The figure of the "hero-discoverer" comes to the fore in enterprises such as those undertaken by the Dilettanti and in other exploration campaigns (see fig. 9), but adventure and documentation were not their sole motivation. Particularly in England, the romanticization of ruins in art and literature was

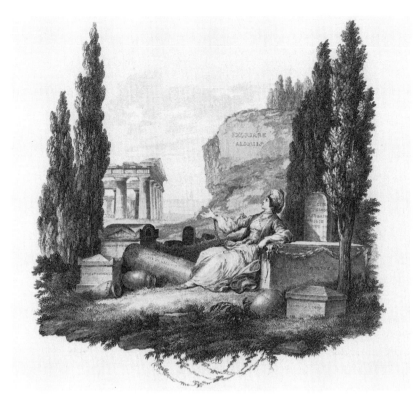

Fig. 6. Anonymous, Greece expiring among classical ruins, engraving from Marie-Gabriel-Auguste-Florent, Comte de Choiseul-Gouffier, *Voyage pittoresque de la Grèce*, 1782. Los Angeles, The Getty Research Institute for the History of Art and the Humanities, acc. 84-B22325.

Fig. 7. Constantine Athanassiou, view of Philopappos Monument, Athens, ca. 1875, albumen print. Los Angeles, The Getty Research Institute for the History of Art and the Humanities, acc. 92.R.84 (04.11.03).

accompanied by fierce commitment to the Greek independence movement. The personification of Greece expires among the devastated gravestones of the past on the title page of the Comte de Choiseul-Gouffier's *Voyage pittoresque de la Grèce* (1782; fig. 6); the inscription calls for an avenger to arise — *exoriare aliquis* — and break the chains of oppression.[26] Philhellenic sentiments coincided with the colonialist agendas of northern European powers and the growing competition among nations eager to "rescue" neglected monuments for display in the halls of national museums. Entire monuments were removed from Greece, the Middle East, and Egypt and repurposed not only for the entertainment of Continental and North American audiences but also for their edification. Written between 1838 and 1856, the correspondence of Sir Charles Fellows details a telling struggle to ensure that the monumental tombs, dismantled in Lycia and shipped to the British Museum, were installed according to scientific and not merely aesthetic principles.[27]

The literature of the "picturesque voyage," a collaborative effort of artists and writers to create beautifully illustrated travel books, is well represented in the collections of the Research Institute by important milestone publications of Vincenzo Coronelli, Pierre Gilles, Jean-Pierre-Laurent Houël, Jean-Claude-Richard de Saint Non, and others.[28] In these works, the emphasis on ever more factual portrayals of the forms and varieties of ancient architecture contrasts with their setting in exotic or pastoral landscapes peopled by natives in local costume. Informed by the romantic perceptions with which many European travel writers and artists came equipped, rather than by accurate ethnographic information, the illustrations that accompanied narratives about classical and biblical ruins tend to emphasize timeless beauty and the survival of a precious cultural patrimony; the representations of distant "Others" often hint at degeneration beneath the surface of exotic and opulently decorated structures. Such books stimulated the taste for picturesque and fantastic settings, irregularity, and intricate design, and they played a significant role in popularizing hybrid revival styles and "oriental" motifs in gardens, pavilions, and the decorative arts. Well-known examples are Thomas and William Daniell's aquatints in *Oriental Scenery* (1803, p. 65) and the plates in the monumental *Description de l'Egypte* (1809–1828), published at the request of the emperor Napoleon.[29]

Pictorial traditions established during the seventeenth and eighteenth centuries had a decided impact on photography of the mid-nineteenth century and after. Decaying monuments were often framed in terms of contemplation and nostalgic reverie, as in the photographs of English abbeys by Roger Fenton (pp. 52–53) or Austin Whittlesey's 1916 portrayal of a pensive figure seated among Roman and Islamic remains in Morocco (p. 21).[30] The proliferation of photography almost immediately following its invention is a witness to the democratization of the Grand Tour. Travel became more of a possibility for the middle classes, and like the prints acquired by sixteenth-century visitors to Rome, the photograph offered a means of collecting — or recollecting — the past as a souvenir. Constantine Athanassiou's 1875 image

Fig. 8. **Anonymous,** the Acropolis viewed from Philopappos Hill, Athens, ca. 1865, albumen print. Los Angeles, The Getty Research Institute for the History of Art and the Humanities, acc. 92.R.84 (04.01.04).

Fig. 9. **Alfred P. Maudslay,** excavations at Palenque, Mexico (detail), ca. 1880s, albumen print. Los Angeles, The Getty Research Institute for the History of Art and the Humanities, acc. 94.R.31.

Fig. 10. R. Choveaux, destruction of pavilions at the Colonial Exposition in Paris, 1931, glass stereograph. Los Angeles, The Getty Research Institute for the History of Art and the Humanities, acc. 97.R.5.

Fig. 11. Ian Hamilton Finlay with Michael Harvey, *Of Famous Arcady Ye Are*, 1977, silk screen. Los Angeles, The Getty Research Institute for the History of Art and the Humanities, acc. 890144**.

of a camera tripod erected next to the Monument of Philopappos in Athens, its facade covered with graffiti (fig. 7), or that of two people gazing upon the Acropolis in about 1865 (fig. 8), anticipates the impact of mass tourism and emphasizes the pivotal role assumed by the viewer.[31] Antiquity became a birthright, part of the cultural inheritance of ever-widening sectors of society. Like students who arranged the *Hellenicorama* cards in any of thousands of combinations as models for practicing watercolor drawing (p. 60), travelers could recreate their own idealized landscapes in the form of photograph albums.[32] The power of such images to frame the historical study of ruins in aesthetic terms, while appearing to present objective documentation, constitutes a "virtual discourse" that continues to shape the understanding and interpretation of these monuments.

The photographs in the Research Institute's holdings also served the technical needs of archaeology. Among the useful applications of the photographic process, argued its champions, was the ability to produce an identical facsimile of ancient inscriptions that previously had to be copied by hand. Within months after the announcement of the invention of the daguerreotype process, photographers such as Joly de Lotbinière had already produced the first views of the antiquities of Athens.[33] From this point on, photography became an indispensable tool in the study of archaeological monuments. At the end of the nineteenth century, the sculptor Urbain Basset was part of an expeditionary team sent to Cambodia by the French government to make casts of the sculptures at the Khmer temples of Angkor (p. 70). Basset took views of buildings freshly emerging from the undergrowth and captured the intricacies of the decorative reliefs, a unique record of which survives in a set of thirty-six albumen prints.[34] Although amateur photographs, they are important registers of a rich architectural heritage that has since been diminished by war and vandalism. Cyanotype photographs of the excavations at Philippeville in Algeria likewise provide rare visual documentation of the Roman port town of Rusicada, later built over by the French colonial administration.[35] Whether taken for the purposes of technical documentation or sight-seeing, many of these early photographs of archaeological sites capture thematic elements that become leitmotifs: ruins appear as stone topiaries in an Arcadian garden paradise (p. 50), and lost civilizations are reclaimed from the uncivilized wilds of jungle and desert (fig. 9 and p. 27).[36]

The vast paper repertory of world antiquities created by artists and photographers since the Renaissance gives credence to the idea that ruins are a universal inheritance. It is a short step from this notion to a justification for the appropriation of ruins by governments keen to demonstrate national identities and the power of empire. If ruins functioned as "theme parks" of sorts for Renaissance pilgrims to the eternal city and patrician owners of country estates, nowhere is this association more plainly expressed than in the context of the international world's fairs. At colonial expositions, in particular, archaeological landmarks such as Angkor Wat and the Baths of Diocletian were reconstituted as cultural commodities. An unusual set of

glass stereographs made at the close of the 1931 Colonial Exposition in Paris portrays the dismantling of the pavilions—ruins of ruins, where counterfeit sphinxes and an obelisk stand guard over the rubble (fig. 10) and plaster busts of emperors crash to the floor of imperial palaces.[37] Part of the appeal of these stereo views, as well as the three-dimensional Englebrecht theater thought to represent the 1755 Lisbon earthquake and the genre of disaster postcards (pp. 45 and 54–57), lies in the thrill of fear and pleasure that pictures of destruction and catastrophe communicate.[38] The destruction of the pavilions, which were erected for one of the last colonial expositions held, also signifies the artificiality of decontextualized ruins and hints at the demise of the colonialist enterprise.

In the space of this short essay, it is not possible to touch on the myriad ways in which the ruined and the fragmentary reverberate in contemporary visual art and culture. From the Research Institute's exceptional twentieth-century archives, we may take one example that unites many of the themes that ruins evoke. In the work of concrete poet and garden designer Ian Hamilton Finlay, multiple metaphors of antiquity are realized in the artist's work, particularly in his image poems, emblems, sculptures, and landscape installations. The Ian Hamilton Finlay Papers contain examples of fine press prints, publications, and an extensive correspondence that reveals the artist's often militant engagement in a "neo-classical rearmament."[39] At Finlay's Little Sparta, broken columns, pedestals, and chiseled inscriptions transform the landscape of Stonypath, Scotland, into a vehicle for his cultural critique. *Of Famous Arcady Ye Are* (1977) is one of several emblematic reinterpretations of a topic addressed in paintings by Guercino, Poussin and others (fig. 11). The original versions depict the pastoral utopia of Arcadia, inhabited by shepherds who approach a tomb bearing the inscription *Et in arcadia ego* (even in Arcadia, I, Death, hold sway). Substituting a tank for the funeral monument, Finlay evokes death-in-paradise themes as a commentary on the destructive elements in contemporary culture. Other works combine classical quotations with the iconography of French revolutionary terror in a stand against modern philistinism. As has long been the practice of artists, architects, and archaeologists, Finlay recombines the visual idioms of antiquity to defend the values of the past for the present and future. At the University of California at San Diego, his installation of rough blocks, carved with the Latin inscription *unda* (wave) and resembling a fallen architrave from an imperial ruin, calls the viewer to contemplate the significance of classical traditions on the Pacific coast. In a time and place where monuments of the distant and near past are swiftly discarded, it poses a provocative, fitting challenge.

Notes

1. The Research Institute's rare books and archival holdings offer a substantial body of unpublished or little-known sources. The materials discussed here are held in the Special Collections of the Getty Research Institute in Los Angeles and are available for consultation and research. The GRI's on-line catalog, IRIS, provides further information on these and related resources (http://www.getty.edu/gri).

2. Aspects of the visual representation of ruins have been explored in several suggestive studies of the intellectual afterlife of classical antiquity. See Salvatore Settis, "Des ruines au musée: La destinée de la sculpture classique," *Annales: Economies, sociétés, civilisations* 48, no. 6 (1993): 1347–80, esp. 1378; and Salvatore Settis, "Continuità, distanza, conoscenza. Tre usi dell'antico," in idem, ed., *Memoria dell'antico nell'arte italiana* (Torino: Giulio Einaudi Editore, 1986), 3: 373–486. See also Alain Schnapp, *The Discovery of the Past* (New York: Abrams, 1996). On ruins, memory, and writing see Hartmut Böhme, "Die Ästhetik der Ruinen," in Dietmar Kamper and Christoph Wulf, eds., *Der Schein des Schönen* (Göttingen: Steidl Verlag, 1989), 287–304.

3. Johann Huttich, *Collectanea antiquitatum in urbe atque agro Moguntino repertarum* (Mainz: Johann Schoeffer, 1525), pl. C; acc. 85-B26875.

4. Ambrogio Leone, *De Nola* ... (Venice: Giovanni Rubri Vercellani, 1514), plate at xi, acc. 90-B32941; Marco Fabio Calvi, *Antiquae urbis romae cum regionibus simulachrum* (Rome: Valeius Dorichus Brixiensis, 1532), acc. 87-B1793.

5. Johann Georg Keyssler, *Antiquitates selectae septentrionalis et celticae* ... (Hannover: Nicolai Foerster, 1720), pls. at 44, acc. 94-B18715.

6. Inigo Jones, *The Most Notable Antiquity of Great Britain, vulgarly called Stone-Heng, on Salisbury Plain* (London: J. Flesher, 1655), acc. 85-B25912; William Stukeley, *Itinerarium curiosum; or, An account of the antiquities, and remarkable curiosities in nature or art, observed in travels through Great Britain* (London: Baker & Leigh, 1776 [1725]), acc. 88-B3660. On the historiography of megaliths, see John Michell, *Megalithomania: Artists, Antiquarians and Archaeologists at the Old Stone Monuments* (Ithaca: Cornell Univ. Press, 1982).

7. Aegidius Sadeler, *Vestigi delle antichità di Roma, Tivoli, Pozzuolo, et altri luochi* (Rome: Gio Iacomo de Rossi, 1660), acc. 82-B2135. Several of the plates were engraved by Marco Sadeler, using reduced copies originally published in Etienne Du Pérac's work of the same title first issued in 1575. The caption under the view of the Baths of Caracalla notes that several columns were given by Pius IV to the Grand Duke of Tuscany.

8. The photograph of the Orsini castle is in the Research Institute's Max Hutzel collection (acc. 94-F92), which comprises some 60,000 photographs and 76,000 negatives of the architecture and interior decoration of churches, palazzi, and other notable buildings, taken between the 1960s and the 1980s, primarily in the smaller provincial towns of Italy.

9. Pompeo Sarnelli, *Guida de' forestieri; curiosi di vedere, e d'intendere le cose più notabili della regal città di Napoli* ... (Naples: A spese di Antonio Bulifon, 1688), plate at 54, acc. 85-B309.

10. Among the most frequently illustrated sites are the imposing remains of the Temple of Bacchus (second century C.E.) at Baalbek. A number of engravings were

prepared by Louis-François Cassas, who published a selection of them in *Voyage pittoresque de la Syrie, de la Phenicie, de la Palestine, et de la Basse Egypte* (Paris: n.p., 1799), acc. 840011*. The Hutzel collection (see note 8) documents further examples of churches built into the remains of classical temples, including San Pietro in Albe, San Salvatore in Spoleto, Santa Cristina in Bolsena, San Salvatore in Campi Vecchio, and Santa Maria Maggiore in Lanciano.

11. Vincenzo Mirabella e Alagona, *Dichiarazioni della pianta delle'antiche Siracuse*...(Naples: Lazarro Scoriggio, 1613), plate at 28–29, acc. 85-B27073.

12. Antoine Lafréry, *Speculum romanae magnificentiae* (Rome: Antoine Lafréry et al., 1544[?]–1602), acc. 91-F104. Giovanni Battista Piranesi, *Trofeo o sia magnifica colonna coclide*...(Rome, 1775–1779), acc. 90-B22638. Statues of Trajan and Marcus Aurelius were replaced by figures of the saints in the years 1588 and 1589.

13. The Research Institute's edition of Francesco Colonna's *La Hypnerotomachia di Poliphilo* (Venice: In Casa de' Figliouoli di Aldo, 1545), acc. 87-B3229, is illustrated with woodcuts from the original 1499 Aldine edition. Among the many architectural and archaeological treatises in the Getty collections, see, for example, Sebastiano Serlio, *Tutte l'opere d'architettura, libro III* (Venice: Francesco Marcolino da Forli, 1540), acc. 85-B6927; Andrea Palladio, *I quattro libri dell'architettura* (Venice: Dominico de'Franceschi, 1570), acc. 86-B23467; Andrea Palladio, *Le antichità di Roma* (Venice: Mattia Pagan, 1555), acc. 86-B2421; Francesco Bianchini, *Del palazzo de' Cesari* (Verona: Pierantonio Berna, 1738), acc. 85-B24331; Francesco Bianchini, *Camera ed iscrizioni sepulcrali de' liberti*...(Rome: Giovanni Maria Salvioni, 1727), acc. 82-B1468. Three manuscript volumes on the archaeological materials from the vicinity of Aquileia (acc. 850507), never printed, supplement the published folios by Gian Domenico Bertoli, *Le Antichità d'Aquileja profane e sacre*...(Venice: Giambatista Albrizzi, 1739).

14. Francesco Bianchini, *La istoria provata con monumenti e figurata con simboli de gli antichi* (Rome: Antonio de Rossi, 1697), acc. 93-B4166. Examples of the encyclopedic approach to antiquity include Anne-Claude-Philippe, Comte de Caylus, *Recueil d'antiquités égyptiennes, étrusques, grecques et romaines* (Paris: Desaint & Saillant, 1752–1767), acc. 92-B25956; and Bernard de Montfaucon, *Antiquité expliquée et représentée en figures* (Paris: Florentin Delaulne, 1719), acc. 86-B18669.

15. A tendency to overlay and improve the variety (and ordinariness) of ancient art and architecture with a purified Neoclassical style is apparent in the extensive series of engravings made by Pietro Santi Bartoli in collaboration with G. P. Bellori. See, for example, G. P. Bellori, *Le pitture antiche del sepolcro de Nasonii nella via Flaminia*...(Rome: G.B. Bussotti, 1680), acc. 88-B4269. On the history of illustrating ancient sites and monuments, see Biblioteca Comunale dell'Archiginnasio, *L'Immagine dell'antico fra settecento e ottocento. Libri di archeologia nella Biblioteca Comunale dell'Archiginnasio*, exh. cat. (Casalecchio di Reno: Grafis Edizioni, 1983).

16. The etching by Giovanni Battista Piranesi, circa 1740–1743, acc. 900153B*, depicts the ruins of an ancient tomb and aqueduct.

17. Robert Adam, *The Works in Architecture of Robert and James Adam, Esquires*...(London: P. Elmsly, 1778–1779), acc. 88-B20049, frontispiece by Antonio Zucchi.

18. Engravings of the Roman ruins at Nîmes by Charles-Louis Clérisseau illustrate *Antiquités de la France,* vol. 1: *Monumens de Nismes* (Paris: P. Didot l'aîné, 1804 [1778]), acc. 88-B2179. On the visual representations of this site, see Gustav Gamer, "'A la font de Nîmes…' — Der Quellbezirk–antike Gestalt und nachantikes Bild," *Antike Welt* 4 (1989): 36–56.

19. Anonymous, Servili Tomb drawings, circa 1500, plan and perspectives of exterior and interior with notes and measurements, acc. 850037*. Marie-Joseph Peyre, *Recueil de morceaux d'architecture et de divers fragmens de monumens antiques faites en Italie…,* circa 1753–1785, acc. 840015*.

20. Sketchbook attributed to Charles Percier (acc. 950016), probably made about 1790 after Percier completed his project drawings of the Column of Trajan.

21. Jean-Nicholas Huyot, architectural restoration of the Temple of Fortuna Primigenia at Praeneste, circa 1815–1820, acc. 870681*. Attributed to Huyot, it is possible that these are student copies after Huyot's drawings exhibited at the 1815 Salon. Simon-Claude Constant-Dufeux, volume of sixty-one leaves of record drawings of ancient monuments, 1825–1833, acc. 890252*. Matthieu-Prosper Morey, architectural drawings of 1836–1837, acc. 870626*. See also the unpublished measured drawings of nine temples at Paestum and in Sicily by the architect of the Kremlin, Konstantin Andreevitch Thön (1794–1881), *Temples de Sicile et de Pestum, mesurés et dessinés,* circa 1820, acc. 920063*.

22. Jacques-Louis David, album of ninety-nine sketches (known as "album 11"), circa 1775–1784, acc. 940049*. Several of these sketches are reproduced in Richard J. Campbell and Victor Carlson, *Visions of Antiquity: Neoclassical Figure Drawings* (Los Angeles: Los Angeles County Museum of Art, 1993), 192–93.

23. Hubert Robert, sketchbook, volume of seventy-five pencil drawings, circa 1790–1800, acc. 930069. See Philippe Junod, "Ruines anticipées ou l'histoire au futur antérieure," in idem, *L'homme face à son histoire* (Lausanne: Payot, 1983), 36–39.

24. Joseph Michael Gandy, *The Persian Porch and the Place of Consultation of the Lacedemonians,* circa 1816, watercolor and gouache over pen and pencil, acc. 910072*. The stage designs by Gandy consist of 125 watercolors for works by Aeschylus, Sophocles, Euripides, Shakespeare, Milton, Dante, and Ossian, dating to about 1820 (acc. 910083*). Arches and rusticated columns are characteristic of classical revival stage sets, for example, in designs by Joseph Routier for the theater at Aix en Provence (acc. 880300*) and by Alessandro Sanquirico (acc. 880230*). Charles Gours conceived a complete reconstruction of an Assyrian palace for the "Theatre de Sete" of about 1900 (870454*).

25. The drawing by Frederick MacKenzie, after a sketch by William Gell, is among a collection of drawings and letters of the Dilettanti Society held by the Research Institute (acc. 840199). Engravings appeared in the Society's *Antiquities of Ionia* (London: Society of Dilettanti, 1797), acc. 84-B778. In addition to letters by William Gell (acc. 840199) and a manuscript on the topography of Boeotian Thebes written in 1802 by Jean-Denis Barbie de Bocage (acc. 870054), the Research Institute holds more extensive correspondence by archaeologist John Turtle Woods (acc. 860962), who excavated at Ephesos in Asia Minor.

26. *Greece Expiring among Classical Ruins,* engraving from Marie-Gabriel-Auguste-Florent, Comte de Choiseul-Gouffier, *Voyage pittoresque de la Grèce,* vol. 1 (Paris: 1782), acc. 84-B22325. A perceptive study of the literature of travel is David Constantine, "The Question of Authenticity in Some Early Accounts of Greece," in G. W. Clarke, ed., *Rediscovering Hellenism: The Hellenic Inheritance and the English Imagination* (Cambridge: Cambridge Univ. Press, 1989), 1–22.

27. Sir Charles Fellows (1799–1860) discovered Xanthos in 1838. His correspondence describes the removal of the marbles and disputes surrounding their acquisition and installation in the British Museum (acc. 970014).

28. Vincenzo Coronelli, *Memorie istoriografiche delli regni della Morea, e Negroponte* . . . (Amsterdam: Wolfgang, Waesberge et al., 1686), acc. 86-B10385; Pierre Gilles, *De topographia Constantinopoleos libri quattor* (Lyon: G. Rouille, 1562), acc. 82-B2108; Jean-Pierre-Laurent Houël, *Voyage pittoresque des isles de Sicile, de Malte et de Lipari* . . . (Paris: De l'Imprimerie de Monsieur, 1782–1787), acc. 86-B12509; Jean-Claude-Richard de Saint Non, *Voyage pittoresque, ou, Description des royaumes de Naples et de Sicile* (Paris: Imprimerie de Clousier, 1781–1786), acc. 88-B19555; and numerous other titles.

29. Thomas Daniell, *Hindoo Excavations in the Mountain of Ellora* . . . (London: T. Daniell, 1803), acc. 89-B11520. *Description de l'Egypte; ou, Recueil des observations et des recherches qui ont été faites en Egypte pendant l'expédition de l'armée française* (Paris: De l'Imprimerie impérial, 1809–1828), acc. 83-B7948. For a historical critique of three centuries of travel accounts from a post-colonial perspective, see Mary Louise Pratt, *Imperial Eyes: Travel Writing and Transculturation* (London: Routledge, 1992).

30. Several of Fenton's views are published in William and Mary Howitt, *Ruined Abbeys and Castles of Greek Britain: The Photographic Illustrations by Bedford, Sedgfield, Wilson, Fenton, and Others* (London: A. W. Bennett, 1862). Other examples of nineteenth-century photography of English abbeys at the Research Institute include sixty individual prints and three albums of photographic views of Medieval architecture in Great Britain (acc. 96.R.32, acc. 90.R.30). The architect Austin Cruver Whittlesey's photograph of the twelfth-century C.E. minaret of the Hasan Mosque at Rabat (Morocco) is one of 1,530 documentary images he assembled in seventeen albums on the architecture of Spain, North Africa, France, and Italy (acc. 84.R.1).

31. These photographs are part of a collection of a thousand views of Greece known as the Gary Edwards Collection (acc. 92.R.84), which represents the work of many Northern European and Greek photographers active in Italy, Greece, and Turkey between 1840 and 1900. Other important holdings include albumen photographs of Athens by Gabriel de Rumine, dating to about 1859 (acc. 95.R.23), and by F. A. Oppenheim, *Photographies d'Athènes* (Dresden: n.p., 1854), acc. 90.R.76.

32. Anonymous, *Hellenicorama, or Grecian Views* (London: J. Burgis, circa 1800–1825), acc. 94.R.57. A critical consideration of archaeological photography is offered by Michael Shanks, "Photography and Archaeology," in B. L. Molyneaux, ed., *The Cultural Life of Images: Visual Representation in Archaeology* (London: Routledge, 1997), 73–107.

33. Reporting on the daguerreotype process to the French Academy of Sciences, François Arago stressed the value photography would have held for Napoleon's Egyptologists in copying hieroglyphics and inscriptions accurately. See Helmut and Alison Gernsheim, *L. J. M. Daguerre: The History of the Diorama and the Daguerreotype* (New York: Dover Publications, 1968), 95 and fig. 50. See also Andrew Szegedy-Maszak, "A Perfect Ruin: Nineteenth-Century Images of the Colosseum," *Arion* 2, no. 1 (1992): 115–42, esp. 115.

34. For the most part unpublished, the thirty-six photographs taken by Urbain Basset date to about 1896 and show details of temple architecture, sculpture, views of the monuments with local guides posed below, and a portrait of the expedition members (acc. 96.R.127). Views of Angkor Wat and Angkor Thom are also included in the photographic travel albums assembled by Paul Fleury (circa 1896–1918), together with extensive visual documentation of India, China, and Latin America (acc. 91.R.5).

35. H. Ranoux and L. Bertrand, *Rusicade; théâtre romain, Philippeville le 15 o[cto]bre 1895*, album of thirty cyanotype photographs of the site and finds of sculpture, acc. 90.R.1.

36. The view of Palenque in Mexico by Alfred Percival Maudslay is one of a collection of early photographs of Aztec, Mayan, and Zapotec ruins in Mexico (acc. 94.R.31). Désiré Charnay, a French photographer sent to Mexico by the French government, is represented in several collections (acc. 94.R.31, 95.R.126*). Skeen and Scowen were among the photographic firms based in Colombo, Sri Lanka, that distributed images of the remains of Buddhist monasteries (acc. 96.R.52).

37. In addition to the series of glass stereographs made by R. Choveaux at the 1931 Colonial Exposition in Paris (acc. 97.R.5), the Research Institute has substantial holdings of original publications and ephemera from the world's fairs and international expositions, where archaeological and ethnographic reconstructions of "primitive" buildings and lifeways are signifiers for a range of colonialist perceptions. For further discussion, see Paul Greenhalgh, *Ephemeral Vistas: The Expositions Universelles, Great Exhibitions and World's Fairs, 1851–1939* (Manchester: Manchester Univ. Press, 1988), 69–73.

38. The seven hand-colored etchings, forming an optical theater when erected in a slotted stand, most likely represent the Lisbon 1755 earthquake. The set was published by Martin Engelbrecht, *Præsentation eines Erdbebens* (Augsburg: Martin Engelbrecht, late 1750s), acc. 96.R.39.

39. The Ian Hamilton Finlay Papers (acc. 890144) consist of manuscripts, correspondence, prints, and photographs related to projects dating between 1967 and 1992 and the controversies they sparked. The full range of Finlay's poetry and art is discussed by Yves Abrioux (with Stephen Bann) in *Ian Hamilton Finlay: A Visual Primer* (London: Reaktion Books, 1985).

Selected Bibliography

Althöfer, Heinz. "Fragmente und Ruine." *Kunstforum International* 19 (1977): 57–169.

Aston, Margaret. "English Ruins and History: The Dissolution and the Sense of the Past." *Journal of the Warburg and Courtauld Institutes* 36 (1973): 231–55.

Baridon, Michel. "Ruins as a Mental Construct." *Journal of Garden History* 5, no. 1 (1985): 84–96.

Biblioteca Comunale dell'Archiginnasio. *L'Immagine dell'antico fra settecento e ottocento. Libri di archeologia nella Biblioteca Comunale dell'Archiginnasio,* exh. cat. Casalecchio di Reno: Grafis Edizioni, 1983.

Biehn, Heinz. *Residenzen der Romantik.* Munich: Prestel, 1970.

Benjamin, Walter. *The Origin of German Tragic Drama.* London: NLB, 1977.

Böhme, Hartmut. "Die Ästhetik der Ruinen." In Dietmar Kamper and Christoph Wulf, eds., *Der Schein des Schönen,* 287–304. Göttingen: Steidl, 1989.

Böhringer, Hannes. "Die Ruine kann man nicht bauen — sie entsteht." *Werk, Bauen und Wohnen* 72, no. 6 (1985): 52–56.

Braham, Allan. "Piranesi as Archaeologist and French Architecture in the Late Eighteenth Century." In *Piranèse et les Français,* 67–76. Rome: Edizione dell'Elefante, 1978.

Brumfield, William Craft. *Lost Russia: Photographing the Ruins of Russian Architecture.* Durham, N.C.: Duke Univ. Press, 1995.

Buck-Morss, Susan. *The Dialectics of Seeing: Walter Benjamin and the Arcades Project.* Cambridge, Mass.: MIT Press, 1989.

Butler, Rex. "Ruins in Concrete." *Art and Text,* no. 48 (1994): 34–39.

Crawford, Donald. "Nature and Art: Some Dialectical Relationships." *Journal of Aesthetics and Art Criticism* 42 (1983): 49–58.

Charlesworth, Michael. "The Ruined Abbey: Picturesque and Gothic Values." In Stephen Copley and Peter Garside, eds., *Politics of the Picturesque: Literature, Landscape and Aesthetics since 1770,* 62–80. Cambridge: Cambridge Univ. Press, 1994.

Daemmrich, Ingrid G. "The Ruins Motif as Artistic Device in French Literature." *Journal of Aesthetics and Art Criticism* 30, no. 4 (1972): 449–57; 31, no. 1 (1972): 31–41.

De Lachenal, Lucilla. *Spolia: Uso e reimpiego dell'antico dal III al XIV secolo*. Milan: Longanesi, 1995.

De Toulza, Guy Ahlsell, et al., eds. *Le "Gothique" retrouvé avant Viollet-le-Duc*, exh. cat. Paris: Caisse Nationale des Monuments Historiques et des Sites, 1979.

Direction du Patrimoine, avec le concours de la caisse National des Monuments Historiques et des Sites, et de l'Association pour la Connaissance et la Mise en Valeur du Patrimoine. *Faut-il restaurer les ruines?* Actes des colloques de la Direction du Patrimoine, no. 10. Paris: Picard, 1991.

Donato, Eugenio. "The Ruins of Memory: Archaeological Fragments and Textual Artifacts." *Modern Language Notes* 93 (1978): 575–96.

Forché, Carolyn. *Against Forgetting: Twentieth-Century Poetry of Witness*. New York: Norton, 1993.

Foucart, Bruno. "Même les ruines ressuscitent." *Connaissance des arts*, no. 478 (1991): 98–105.

Fowler, Don D. "Uses of the Past: Archaeology in the Service of the State." *American Antiquity* 52 (1987): 230–47.

Francblin, Catherine. "Charles Simonds: Bâtisseur de ruines." *Art Press*, no. 45 (1981): 14–15.

Galard, Jean. "La poétique des ruines." *Word & Image* 4, no. 1 (1988): 231–37.

Gasiorowski, Eugeniusz. "Die Ruine als Gedenkstatte und Mahnmal." *Österreichische Zeitschrift für Kunst und Denkmalpflege* 33, nos. 3/4 (1979): 81–90.

Gilman, Richard. *Decadence, the Strange Life of an Epithet*. New York: Farrar, Straus, & Giroux, 1979.

Goldstein, Laurence. *Ruins and Empire: The Evolution of a Theme in Augustan and Romantic Literature*. Pittsburgh: Univ. of Pittsburgh Press, 1977.

Hartmann, Günter. *Die Ruine im Landschaftsgarten: Ihre Bedeutung für den frühen Historismus und die Landschaftsmalerei der Romantik*. Worms: Werner, 1981.

Headley, Gwyn, and Wim Meulenkamp. *Follies: A National Trust Guide*. London: Cape, 1990.

Heckscher, Wilhelm Sebastian. *Die Romruinen: Die geistigen Voraussetzungen ihrer Wertung im Mittelalter und in der Renaissance*. Würzburg: R. Mayr, 1936.

Hetzler, Florence M. "Causality: Ruin Time and Ruins." *Leonardo* 21, no. 1 (1988): 51–55.

———. "The Aesthetics of Ruins, a New Category of Being." *Journal of Aesthetic Education* 16, no. 2 (1982): 105–8.

Hoffmann, Detlef. "Deutsche Ruinenfotos: Bearbeitung oder Verdrängung eines unvermeidlichen Endes?" *Kairos* 3, nos. 1/2 (1988): 26–32.

Holländer, Hans. "Fragmente anläßlich des Schlegelschen Igels — Fragments on the Occasion of the Schlegelian Hedgehog." *Daidalos*, no. 31 (1989): 88–101.

Hunt, John Dixon. "Picturesque Mirrors and the Ruins of the Past." *Art History* 4, no. 3 (1981): 254–70.

———. "Ut pictura poesis, the Picturesque, and J. Ruskin." *Modern Language Notes* 93, no. 5 (1978): 794–818.

Jackson, John Brinckerhoff. *The Necessity for Ruins, and Other Topics.* Amherst: Univ. of Massachusetts Press, 1980.

Janowitz, Anne F. *England's Ruins: Poetic Purpose and the National Landscape.* Cambridge, Mass.: Blackwell, 1990.

Jonak, Ulf, et al. "Ruinoses und Fragmentarisches in der Architektur." *Architekt,* no. 8 (1994): 433–69.

Jones, Barbara Mildred. *Follies and Grottoes.* London: Constable, 1974.

Jullian, René. "Le thème des ruines dans la peinture de l'époque néo-classique en France." *Bulletin de la Société de l'histoire de l'art français* (1976): 261–72.

Junod, Philippe. *Ruines anticipées ou l'histoire au futur antérieur.* Lausanne: Payot, 1983.

Ketcham, Diana. *Le Désert de Retz: A Late Eighteenth-Century French Folly Garden — The Artful Landscape of Monsieur de Monville.* Rev. ed. Cambridge, Mass.: MIT Press, 1994.

Krier, Leon. "The Love of Ruins, *or* the Ruins of Love." *Modulus: The University of Virginia Architectural Review* 16 (1983): 48–61.

Kultermann, Udo. "La ciudad caída: Ruinas y visiones laberínticas de ciudades." *Goya,* nos. 217/218 (1990): 87–95.

———. "The Fallen City of Man (Urban Vision in the Image of Ruins and Labyrinths)." *Ars,* no. 1 (1994): 103–11.

Lamoureux, Johanne. "La théorie des ruines d'Albert Speer ou l'architecture *futuriste* selon Hitler." *RACAR: Revue d'art Canadienne* 18, nos. 1/2 (1991): 57–63.

Lee, Antoinette J. "Cultural Diversity in Historic Preservation." *Historic Preservation Forum* 6, no. 4 (1992): 28–41.

Lesnikowski, Wojciech, et al. "On Symbolism of Memory and Ruins." *Reflections,* no. 6 (1989): 68–95.

Levin, Harry. *The Broken Column: A Study in Romantic Hellenism.* Cambridge, Mass.: Harvard Univ. Press, 1931.

Lowenthal, David. *The Past is a Foreign Country.* Cambridge: Cambridge Univ. Press, 1985.

———. "Classical Antiquities as National and Global Heritage." *Antiquity* 62, no. 237 (1988): 726–35.

Macaulay, Rose. *The Pleasure of Ruins.* New York: Walker, 1966.

McFarland, Thomas. *Romanticism and the Forms of Ruin: Wordsworth, Coleridge, and Modalities of Fragmentation.* Princeton: Princeton Univ. Press, 1981.

Minguet, P. "Il gusto delle rovine." *Rivista di estetica* 21 (1981): 3–7.

Michell, John. *Megalithomania: Artists, Antiquarians and Archaeologists at the Old Stone Monuments.* Ithaca: Cornell Univ. Press, 1982.

Modiano, Raimonda. "The Legacy of the Picturesque." In Stephen Copley and Peter Garside, eds., *Politics of the Picturesque: Literature, Landscape and Aesthetics since 1770,* 196–219. Cambridge: Cambridge Univ. Press, 1994.

Monnet, Bertrand. "The Care of Ancient Monuments in France." *Architectural Association Quarterly* 2, no. 2 (1970): 27–36.

Montclos, Claude de. *La mémoire des ruines: Anthologie des monuments disparus en France.* Paris: Mengès, 1992.

Mortier, Roland. *La poétique des ruines en France: Ses origines, ses variations, de la Renaissance à Victor Hugo.* Geneva: Droz, 1974.

Negrin, Llewellyn. "On the Museum's Ruins: A Critical Appraisal." *Theory, Culture and Society* 10, no. 1 (1993): 97–125.

Nochlin, Linda. *The Body in Pieces: The Fragment as a Metaphor of Modernity.* London: Thames & Hudson, 1994.

Patrik, Linda E. "The Aesthetic Experience of Ruins." *Husserl Studies* 3 (1986): 31–55.

Perricone, C., Jr. "Ruins and the Sublime." *Annales d'esthétique* 23/24 (1984/85): 93–101.

Piggott, Stuart. *Antiquity Depicted: Aspects of Archaeological Illustration.* London: Thames & Hudson, 1978.

Poirier, Ann. *Anne et Patrick Poirier,* exh. cat. Milan: Electa, 1994.

Rasch, Wolfdietrich. "Literary Decadence: Artistic Representation of Decay." *Journal for Contemporary History* 17 (1982): 201–18.

Riegl, Alois. "The Modern Cult of Monuments: Its Character and Its Origin." *Oppositions,* no. 25 (1982): 21–51.

Rubinstein, Ruth. "Pius II and Roman Ruins." *Renaissance Studies* 2, no. 2 (1988): 197–203.

Rubio, Lilia Maure. "El viajero y la ilustración: Orígenes ideológicos en la recuperación de la Antigüedad." *Goya,* nos. 235/236 (1993): 53–64.

Ruskin, John. *The Seven Lamps of Architecture.* London: G. Routledge & Sons, 1907.

Schnapp, Alain. *The Discovery of the Past.* New York: Harry N. Abrams, 1997.

Schulze, Ulrich. *Ruinen gegen den konservativen Geist: Ein Bildmotiv bei Caspar David Friedrich.* Worms: Wernersche Verlagsgesellschaft, 1987.

Settis, Salvatore. "Continuità, distanza, conoscenza. Tre usi dell'antico." In Salvatore Settis, ed. *Memoria dell'antico nell'arte italiana,* vol. 3, 373–486. Turin: Giulio Einaudi Editore, 1986.

———. "Des ruines au musée: La destinée de la sculpture classique." *Annales: Économies, sociétés, civilisations* 48, no. 6 (1993): 1347–80.

Simmel, Georg. "The Ruin." In Kurt H. Wolff, ed., *Essays on Sociology, Philosophy and Aesthetics,* 259–66. New York: Harper & Row, 1965.

Simmen, Jeannot. *Ruinen-Faszination: in der Graphik vom 16. Jahrhundert bis in die Gegenwart.* Dortmund: Harenberg, 1980.

Skyrme, Raymond. "*Buscas en Roma a Roma:* Quevedo, Vitalis, and Janus Pannonius." *Bibliothèque d'Humanisme et Renaissance* 44, no. 2 (1982): 363–67.

Springer, Carolyn. *The Marble Wilderness: Ruins and Representation in Italian Romanticism, 1775–1850*. New York: Cambridge Univ. Press, 1987.

Szegedy-Maszak, Andrew. "A Perfect Ruin: Nineteenth-Century Views of the Colosseum." *Arion* 2, no. 1 (1992): 115–42.

Tait, A. A. "Reading the Ruins: Robert Adam and Piranesi in Rome." *Architectural History* 27 (1984): 524–33.

Thacker, Christopher. "Ruines gothiques: Débris pittoresques ou pierres fondamentales?" In *Jardins et paysages: Le style anglais,* 171–82. Villeneuve-d'Ascq: Publications de l'Université de Lille III, 1977.

Thompson, Michael Welman. *Ruins: Their Preservation and Display*. London: British Museum Publications, 1981.

Tronche, Anne. "Anne et Patrick Poirier ou l'espace-temps conditionné." *Opus International*, no. 65 (1978): 34–38.

Tschudi-Madsen, Stephan. *Restoration and Anti-Restoration: A Study in English Restoration Philosophy*. 2nd ed. Oslo: Universitetsforlaget, 1976.

Vowles, Hannah, and Glyn Banks. "Art in Ruins." *Kunstforum International* 106 (1990): 146–49.

Wandschneider, Andrea. *Phantasie und Illusion: Städte, Räume, Ruinen in Bildern des Barock*. Paderborn: Stadt Paderborn, 1996.

Weinshenker, A. B. "Diderot's Use of the Ruin-image." *Diderot Studies* 16 (1973): 309–29.

Woods, Lebbeus. *War and Architecture*. New York: Princeton Architectural Press, 1993.

Zimmermann, Reinhard. *Künstliche Ruinen: Studien zu ihrer Bedeutung und Form*. Wiesbaden: Reichert, 1989.

Zucker, Paul. *Fascination of Decay: Ruins, Relic, Symbol, Ornament*. Ridgewood, N.J.: Gregg Press, 1968.

———. "Ruins—An Aesthetic Hybrid." *Journal of Aesthetics and Art Criticism* 20, no. 2 (1961): 119–30.

Image and Quotation Credits

Every effort has been made to locate all copyright holders for the images and quotations reproduced in this book. The publishers invite any copyright holders they have not been able to reach to contact them so that full acknowledgment may be given in subsequent editions.

The following sources have granted permission to reproduce illustrations and quotations used in this book (numbers refer to the page where the illustration or quotation appears).

p. 20 From *Modern Poetry of the Arab Word*, ed. and trans. Abdullah al-Udhari. Reprinted by permission of Penguin Books. Quoted from *Against Forgetting: Twentieth-Century Poetry of Witness*, published in 1993 by W. W. Norton & Company, Inc.

p. 30 Top: Photo courtesy J. Paul Getty Museum. Bottom: Photo courtesy John Weber Gallery.

p. 35 Courtesy Daniel Libeskind.

p. 45 Courtesy Anne and Patrick Poirier; photo courtesy Sonnabend Gallery.

p. 60 Quoted from *Hymns and Fragments*. Copyright © 1984 by Princeton University Press. Reprinted by permission of Princeton University Press.

p. 60 Quoted from *Letters of Rainer Maria Rilke: 1892-1910*, ed. Jane Bannard Greene and M. D. Herter Norton. Copyright 1945 by W. W. Norton & Company, Inc., renewed © 1972 by M. D. Herter Norton. Reprinted by permission of W. W. Norton & Company, Inc.

p. 66 From *The True Subject: Selected Poems of Faiz Ahmad Faiz*. Copyright © 1988 by Faiz Ahmad Faiz. Reprinted by permission of Princeton University Press. Quoted from *Against Forgetting: Twentieth-Century Poetry of Witness*, published in 1993 by W. W. Norton & Company, Inc.

p. 71 Quoted from *Against Forgetting: Twentieth-Century Poetry of Witness*, published in 1993 by W. W. Norton & Company, Inc.

 Excerpt from *Camera Lucida: Reflections on Photography* by Roland Barthes, translated by Richard Howard. Translation copyright © 1981 by Farrar, Straus & Giroux, Inc. Reprinted by permission of Hill & Wang, ad division of Farrar, Straus & Giroux, Inc.

p. 72 Courtesy Lebbeus Woods.

p. 92 Courtesy Ian Hamilton Finlay.

105

Checklist of the Exhibition

Unless otherwise noted, all objects are from the collections of the Getty Research Institute for the History of Art and the Humanities.

Production and Framing

Etienne de la Rivière
French, d. 1569
Anatomical inset, corpse resting on ruins
Woodcut
Charles Estienne, *De dissectione partium corporis humani*
Paris: Apud Simonem Colinæum, 1545
84-B31171

Anonymous
Imaginary ruins with arcade
Woodcut
Sebastiano Serlio, *Tutte l'opere d'architettura*
Venice: Francesco Marcolino da Forli, 1540
85-B6491

Anonymous
Roman ruins at Mainz, Germany
Woodcut
Johann Huttich, *Collectanea antiquitatum in urbe atque agro Moguntino repertarum*
Mainz: Ioannis Schoeffer, 1525
85-B26875

Marco Sadeler
German, active early seventeenth century
Interior of the Baths of Caracalla, Rome
Engraving
Aegidius Sadeler, *Vestigi delle antichità di Roma Tivoli Pozzuolo et altri luochi*
Rome: Gio. Iacomo de Rossi, 1660
85-B14694

Georges-Louis Le Rouge
French, active late eighteenth century
Column house, artificial ruin in the Désert de Retz, France
Engraving
Détail des nouveaux jardins à la mode
Paris: Chez Le Rouge, circa 1776–1787
88-B1922

Georges-Louis Le Rouge
French, active late eighteenth century
Cross section of column house
Engraving
Détail des nouveaux jardins à la mode
Paris: Chez Le Rouge, circa 1776–1787
88-B1922

Anonymous
Temple of Olympian Zeus, Athens, circa 1860s
Albumen print
96.R.34

Roger Fenton
British, 1819–1869
Tintern Abbey, England, circa late 1850s–1862
Albumen print
96.R.34

Francis Frith
English, 1822–1898
Fountains Abbey, England, circa 1859
Albumen print
96.R.32

Frederick MacKenzie
British, 1788(?)–1854
Theater at Patara, Turkey, circa 1840
Drawing, ink and wash, after a sketch by William Gell
840199*

Frederick MacKenzie
British, 1788(?)–1854
Propylon at Patara, Turkey, circa 1840
Drawing, ink and wash, after a sketch by William Gell
840199*

Giovanni Battista Piranesi
Italian, 1720–1778
Ruins of an ancient tomb and aqueduct, circa
1740s
Etching
900153B*

Giovanni Battista Piranesi
Italian, 1720–1778
Sepulchral urn of Marcus Agrippa, circa 1740s
Etching
900153B*

René-Jacques Charpentier
French, 1733–1770
Ruins of classical architecture and tomb
Engraving
Jacques-François Blondel, *Livre nouveau; ou,
Règles des cinq ordres d'architecture*
Paris: Chés Petit, 1767
93-B6777

Recycling, Reconstruction, Preservation

Anne and Patrick Poirier
French, 1941–, 1942–
Memoria Mundi (No. II), 1990–91
Wood, stone, glass, paper, book, and plaster
Courtesy Sonnabend Gallery, New York

Joseph Michael Gandy
English, 1771–1843
*The Persian Porch and the Place of Consultation
of the Lacedemonians*, circa 1816
Watercolor and gouache over pen and pencil, on
paper
910072*

Bruno Braquehais
French, 1823–1875
Demolition of Vendôme Column, Paris, 1871
Albumen print
95.R.102

Bruno Braquehais
French, 1823–1875
Ruins of Tuileries Palace, Paris, 1871
Albumen print
95.R.102

Alphonse Liebert
French, 1827–1914
Interior court of burned Hôtel de Ville, Paris,
1871
Albumen print
93.R.121*

Anonymous
Hellenicorama or Grecian Views
Cards used for practice of watercolor technique
Aquatint prints, hand colored
London: J. Burgis, circa 1800–1825
94.R.57

Martin Engelbrecht
German, 1684–1756
Præsentation eines Erdbebens
Set of seven etchings, hand colored
Augsburg: Martin Engelbrecht, late 1750s
96.R.39

Anonymous
Excavation of architectural fragments in a
classical landscape
Engraved frontispiece
Anne-Claude-Philippe, Comte de Caylus, *Recueil
d'antiquités égyptiennes, étrusques, grecques et
romaines*
Paris: Desaint & Saillant, 1752–1767
92-B25956

Charles-Louis Clérisseau
French, 1721–1820
Interior of the so-called Temple of Diana at
Nîmes, France
Engraving
Antiquités de la France
Paris: P. Didot l'aîné, 1804
88-B2179

Charles-Louis Clérisseau
French, 1721–1820
Interior of Roman baths and statue of Hygeia at
Nîmes, France
Engraving
Antiquités de la France
Paris: P. Didot l'aîné, 1804
88-B 2179

Nicolas Béatrizet
French, active 1540–1565
The Colonna Sancta at St. Peter's Basilica, Rome
Engraving
Speculum romanae magnificentiae
Rome: Antoine Lafréry et al., 1544(?)–1602
91-F104

Nicolas Béatrizet (?)
French, active 1540–1565
"Pasquino" sculpture in Rome
Engraving
Speculum romanae magnificentiae
Rome : Antoine Lafréry et al., 1544(?)–1602
91-F104

Giovanni Montiroli
Italian, 1807–1879
Views of the Porta Maggiore and the Tomb of the
Baker, Rome
Watercolor
Giuseppe De Fabris, *Porta Gregoriana al
Monumento dell'Acqua Claudia…*
Rome: n.p., 1840
900013*

Giovanni Montiroli
Italian, 1807–1879
Finds from excavations in the area of the Tomb of
the Baker, Rome
Watercolor
Giuseppe De Fabris, *Porta Gregoriana al
Monumento dell'Acqua Claudia…*
Rome: n.p., 1840
900013*

Various makers
Disaster postcards, including scenes of destruction
caused by the 1906 earthquake and fire in San
Francisco and the 1933 earthquake in Long Beach
89.R.46
a. Tivoli Opera House and other San Francisco
buildings
b. Unidentified buildings, San Francisco
c. St. Francis Hotel and Congregational Church,
San Francisco
d. Market Street and City Hall, San Francisco
e. Kearney Street looking south toward the Call
Building and Palace Hotel, San Francisco
f. Huntington Park High School, Long Beach
g. Ruins of unidentified neoclassical pavilion
h. Window display, Compton
i. Ruins of the Los Angeles Times Building,
Los Angeles
j. Movie crew in Compton

Loss, Recuperation, Identity

George N. Barnard
American, 1819–1902
Ruins of railroad depot, Charleston, South
Carolina, 1865
Albumen print
Photographic Views of Sherman's Campaign
New York: George N. Barnard, 1869
J. Paul Getty Museum: 84.XO.1323.61

Felice Beato
British, circa 1830–1903
Sikandrah Bagh after the Slaughter of the Rebels
by the 93rd Highlanders of 4th Panjal N.I., 1858
Albumen print
Lucknow, about 1858
J. Paul Getty Museum: 84.XO.1168.7

W. H. L. Skeen & Co.
British, active 1870s–1890s
Thūpārāma Dāgäba, Sri Lanka, late nineteenth
century
Albumen print
96.R.52

Urbain Basset
French, 1842–1924
Monument at Angkor, Cambodia, with French
expedition members, circa 1896
Albumen print
96.R.127

Urbain Basset
French, 1842–1924
Buddhist sculpture in storage area at Angkor,
Cambodia, circa 1896
Albumen print
96.R.127

Urbain Basset
French, 1842–1924
Exterior view of a building at Angkor, Cambodia,
circa 1896
Albumen print
96.R.127

Félix Bonfils
French, 1829–1885
Gateway to the Temple of Bacchus, Baalbek,
Lebanon, early 1870s
Albumen print
Souvenirs d'Orient
Alais: Félix Bonfils, 1877
J. Paul Getty Museum: 84.XO.1167.38

Austin Cruver Whittlesey
American, d. 1950
Minaret, Hasan Mosque, Rabat, Morocco, 1916
Gelatin silver print
84.R.1

Thomas Daniell
English, 1749–1840
Kailasa Temple at Ellora, India, 1790s
Aquatint print after a drawing by James Wales
*Hindoo Excavations in the Mountain of Ellora;
near Aurungabad, in the Decan, in Twenty-Four
Views*
London: T. Daniell, 1803
89-B11520

Désiré Charnay
French, 1828–1915
Northern building of the Nunnery at Uxmal,
Mexico, circa 1859
Albumen print
95.R.126*

Désiré Charnay
French, 1828–1915
Monumental head at Izamal, Mexico, circa 1859
Albumen print
95.R.126*

Désiré Charnay
French, 1828–1915
Interior, Group of the Columns at Mitla, Mexico,
circa 1859
Albumen print
95.R.126*

Désiré Charnay
French, 1828–1915
"Second Palace" at Mitla, Mexico, circa 1859
Albumen print
95.R.126*

Daniel Libeskind
Polish, 1946–
Extension of the Berlin Museum with the Jewish
Museum Department, 1989–1991
Architectural model
920061

Lebbeus Woods
American, 1940–
Aerial view, *Berlin Free Zone* project, 1990
Mixed media, mainly electrostatic printing,
colored pencil, pastel, and ink on paper
950081**

Lebbeus Woods
American, 1940–
Building facade, *Berlin Free Zone* project, 1990
Mixed media, mainly electrostatic printing,
colored pencil, pastel, and ink on paper
950081**

Irresistible Decay: Ruins Reclaimed
Michael S. Roth with Claire Lyons and Charles Merewether

Michael S. Roth is assistant director of the Getty Research Institute and the head of the Research Institute's Scholars and Seminars Program. His publications include *The Ironist's Cage: Memory, Trauma, and the Construction of History* (Columbia University Press, 1995), *Knowing and History: Appropriations of Hegel in Twentieth-Century France* (Cornell University Press, 1988), and *Psycho-Analysis as History: Negation and Freedom in Freud* (Cornell University Press, 1987). His edited volumes include *History and...: Histories within the Human Sciences* (University Press of Virginia, 1995) and *Rediscovering History: Culture, Politics, and the Psyche* (Stanford University Press, 1994). Dr. Roth is also the guest curator of the Library of Congress's exhibition *Sigmund Freud: Conflict and Culture,* to open in the fall of 1998.

Claire Lyons is curator of archaeology, ancient art, and the classical tradition at the Getty Research Institute. She is the author of *Morgantina: The Archaic Cemeteries* (Princeton University Press, 1996) and the editor, with A. Koloski-Ostrow, of *Naked Truths: Women, Sexuality, and Gender in Classical Art and Archaeology* (Routledge, 1997). Dr. Lyons has published numerous articles focusing on the history of archaeology and early collecting of ancient art, colonization and acculturation in the classical Mediterranean, and representations of gender and sexuality. She is Vice President for Professional responsibilities of the Archaeological Institute of America. Previous exhibitions include *Recollection Reconstruction: Imag(in)ing Antiquity, 1500 to 1900* and *Documents in the History of Classical Archaeology* (Getty Research Institute, 1995), and *The Amasis Painter and His World* (Getty Research Institute, 1986). Dr. Lyons is a contributing curator to the exhibition *Beyond Beauty: Antiquities as Evidence* (J. Paul Getty Museum, 1997–1999).

Charles Merewether is curator of Spanish and Portuguese language cultures at the Getty Research Institute. He has taught at the Associacao Alumni, Sao Paulo, the University of Texas, the Universidad Nacional de Bogotá, the University of Sydney, the Universidad Autonoma, Barcelona, the Universidad Iberoamericana, Mexico City, and the British School at Rome. Dr. Merewether is the author of *What Remains: Ana Mendieta and Her Art* (Routledge, 1998), *Nuevas Momentos del Arte Mexicano/New Moments in Mexican Art* (Turner Libros, 1990), and *Art and Social Commitment: An End to the City Dreams, 1931–48* (Art Gallery of New South Wales, 1984). He has also written extensively on violence and the aesthetics of redemption and more recently on cultural patrimony and memory, the reinvention of modernism in non-European cultures, and monuments and archives. Recent exhibition projects include *Cronicas Americas: A Retrospective of José Bedia* (Museo de Arte Contemporaneo de Monterrey, 1997) and *Kurdistan: In the Shadow of History* (Menil Foundation, 1996).

Bibliographies & Dossiers
The Collections of the Getty Research Institute
for the History of Art and the Humanities

In Print
Russian Modernism
Introduction by Jean-Louis Cohen
Compiled by David Woodruff and Ljiljana Grubišić
ISBN 0-89236-385-1

Incendiary Art: The Representation of Fireworks in Early Modern Europe
Kevin Salatino
ISBN 0-89236-417-3

In Preparation
Maiolica in the Making: The Gentili Archive
Catherine Hess
ISBN 0-89236-500-5

Designed by Bruce Mau with Chris Rowat
Coordinated by Stacy Miyagawa
Type composed by Archetype in Sabon
Printed by Southern California Graphics on Cougar Opaque and Lustro Dull
Bound by Roswell Bookbinding

Bibliographies & Dossiers
Series designed by Bruce Mau Design Inc.